MaiNtENaNt⁹

A JOURNAL OF CONTEMPORARY DADA WRITING & ART

PETER CARLAFTES & KAT GEORGES

EDITORS

THREE
ROOMS
PRESS

NEW YORK
LONDON I BRUSSELS I PARIS I BERLIN I ROME
BASTIA I LONGBOAT KEY I LOS ANGELES I HIROSHIMA
WWW.THREEROOMSPRESS.COM

MAINTENANT: A JOURNAL OF CONTEMPORARY DADA WRITING & ART
ISSUE 9

Editors
Peter Carlaftes & Kat Georges

Contemporary Adviser
Roger Conover

Design & Production
KG Design

Inspiration
Arthur Cravan

ON THE COVER:

TechNoWar
VILHELEM JOZSEF HUNOR
Ink and Digital Illustration
Created especially for Maintenant: A Journal of Contemporary Dada Writing & Art, Issue 9
©2015 Vilhelem Jozsef Hunor I Targu Mures, Romania
http://www.vilhelem.com

ISBN: 978-1-941110-20-1 ISSN 2333-2034

Thanks to all the contributors who have made this journal possible again this year, and thanks to all of
the readers, whose feedback continues to be encouraging. Special thanks to Constance Renfrow and
Rachel Gold for their fine editorial assistance.

MAINTENANT: A JOURNAL OF CONTEMPORARY DADA WRITING & ART
is published annually by Three Rooms Press, New York, NY
For submission details, visit www.threeroomspress.com

Distributed by PGW/Persus (www.pgw.com)

INTRO**DUCTION**

In those days of valor yore,
some commander hollered to the troops

"TAKE NO PRISONERS!"

before sending them right into battle.

No outcome but victory.
The warrior is told to kill or be killed.

And while there have been instances of conquerors
trying to convert an enemy before killing those
who didn't make a quick enough transition,
none ever told their armies

"Bring back the enemy. Nurture them.
Then we can all live happily ever after."

Not a chance.

Until—

TECH-NO PRISONERS!

Things are different now. Like or be Liked.
Give up our selves without a shot being fired.
Surrender with a click instead of a white flag.

We are begging to be taken.

The enemy is invisible. The war unnamed.
We don't yet realize what we are losing.

In the coming best of/worst of times
all we will need to do to survive
is to manufacture a lot of bread and water
on those 3D printers of the future.

Maybe that's enough. Or is it? The past is gone.

MAINTENANT: The Time Is NOW.

CONTENTS

CONTENTS

CONTENTS

MAiNtENaNt⁹

DISCONNECTION #9

photo

ANTONIA ALEXANDRA KLIMENKO

PARIS, FRANCE

NUMBER 9 NUMBER 9 NUMBER 9 NUMBER 9

We are experiencing technical difficulties and are unable to return to our regularly

scheduled program. Please be patient while your system is being scanned. You are

being deep-cleaned and optimized for better speed God speed. Impromptu grimaces

and abusive exclamations are frowned upon. Email and Facebook smiley faces will

be provided for you. Broken hearts are offered only to those who don't already have

one and can't prove they are deserving. You are being monitored for your own protection.

My next comment is blocked for my own safety NUMBER 9 NUMBER 9 NUMBER

After you have stripped down to the bare E-ssentials, please remove any jewelry, any
dentifrice, any and all expression before forming a dotted line. Elevator music is being

piped in for your easy listening. Violins and chamber music are no longer permitted.

Tears threaten performance and stability and cannot be tolerated NUMBER 9 NUMB

ER 9 NUMBER NUMB Warning: your registry is at damage level. 2015 errors have been
detected. System related errors affect all active users and therefore must be eliminated.
JFK,1963 errors, Martin Luther King, 1966 errors, Gandhi, 1947 Elevator music is being
piped in for your easy . . . No, that is not gas you smell . . . Chamber music is no longer

permitted. Tears threaten performance and stability and cannot be tolerated. No, that is

not gas. There is no exit. Please stand by. Please stand by . . . me. Due to circumstances

beyond our control we are unable to return.

ROGER CONOVER

FREEPORT, ME

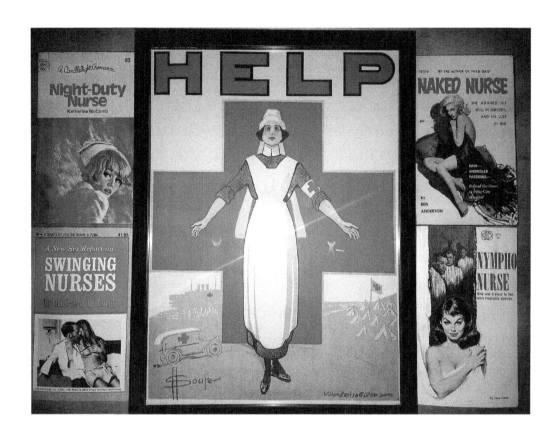

RICHARD RE-PRINCE

photo collage

BRADLEY RUBENSTEIN

BROOKLYN, NY

THE POETRY OF HATING SHIT: AN ESSAY ON AESTHETICS

We are in a banquette at Nell's, well sorted, and I am overwhelmed with a vague sadness all of a sudden—the conversations around the table, a sonic penumbra: who has new tits (girls with names like Coriander and Chloe), who is in rehab ("she has a nasal addiction"), who fucked whom with what (don't ask), and possibly, for the first time in recent memory, I no longer care what I am wearing (Comme des Garçons leather jacket over a vintage Led Zeppelin t-shirt, imitation of Imitation of Christ store-torn jeans, Prada driving shoes, with no socks, as my awesome new ankle tattoo—neo-tribal—is still too fresh and bandaged). Someone comes to take orders, and Damien, who has drawn eyes on the head of his cock with a Sharpie, stands up, takes it out (a Camel Light dangling from his urethra), wags it, and says, ventriloquist-like, "Three Black and Tans and two E's, please." The table dissolves into laughter. I think that a piece of uneaten tofu on the plate in front of me is whispering something important. It is definitely time to leave.

Outside, Albert Oehlen jokingly offers a homeless guy his AmEx card, pulling it away at the last moment and laughing; and Johnny Depp, embarrassed, hangs back, writing him a check. There are suggestions of better places to go in Soho, with names like Spy or Toy or Goy. Gwyneth Paltrow suggests we go to a club called HIV, but we end up tagging along with Ashley Bickerton, Jay MacInerny, Larry Clark, and Kate Moss to someone's loft, which has been decorated with silver helium balloons and glitter and a 15-foot rail of blow on a long mirror on the floor to celebrate either someone's opening or a new record or possibly a cure for AIDS or Sean Landers's new novel. The Julian Schnabel show has drawn a huge crowd and some of the runoff has spilled in. Leonardo DiCaprio is on the floor hoovering from the enormous line with Heath Ledger, and Terry Richardson is snapping Polaroids and muttering things like "fagulous." There is a suite of new Cindy Sherman C-prints on the wall where she is dressed up to look like various members of an SS Death Squad.

Someone who is definitely not a DJ is playing Oasis, and Damon Albarn throws a Guinness bottle through a window. Thurston Moore takes over at the turntables and starts playing The Beatles' *White Album* at half-speed. People start dancing again. Wolfgang Tillmans sees me standing in the kitchen, which was done by Andrea Zittel—the tables fold into the walls, and the cabinets double for growing hydroponic weed—and asks me if I want to meet some girls. "They are really beautiful," he says. "I mean, they are 16, but they look like they're 14." I pass and wander aimlessly around the loft, wishing I had done more Ketamine before we left. I remember that I had come with a date, but since I can't remember her name (ironic, since she only has one, like Moby), it seems a little pointless to ask if anyone has seen her.

There is a small painting of Kurt Cobain or Liam Gallagher that seems to stare at me from the wall in the bathroom as I piss into what I am hoping is a toilet. Someone has scrawled "I Fucked Tracey Emin" on the mirror in Hard Candy Black-Cherry-Bomb lipstick.

Sadie Benning is making a Pixelvision movie in one of the bedrooms starring Matthew Barney and Kristin Oppenheim. They have pulled all the 1,000-thread-count Egyptian cotton sheets off the Frank Gehry Eager Beaver cardboard bed and are pretending to be ghosts. Barney is holding two silver ass plugs over his sheet-covered head, pretending to be a bull-ghost, and starts to mount the Oppenheim ghost, who is alternately saying "boo" and "moo." I melt into the wall and pretend along with them for a while. Someone has written "I smell the blood of les tricoteuses" in orange spray paint on one of the walls, and, feeling a little creeped out, I slip back to the party.

Stavros Niarchos II, René Ricard, John Currin, and Alex Bag are drinking champagne from a bottle in the hallway. As I pass between them, one of them says, "No, she is a female female impersonator. I hear she is in the new Nirvana video . . ." I find a sealed tin of Beluga from Dean & DeLuca on a Philippe Starck princess coffee table and pick it up. I push aside a clutter of untouched Chinese take-out containers and little bottles of Evian. I sit down on the Droog Design couch, cradling the tin, tears welling up uncontrollably, and lean back, marveling at the perfection of it all.

MONA JEAN CEDAR

LOS ANGELES, CA

ASL DADA

D A

1 10

Mona Jean 1/15

ASL DADA

Compiled visual

ROBERT W. PETRICK

NEW YORK, NY

DADA

DADA

This is a word made from just one letter and it is both invertible and a mirror image.
Inkjet print 30" x 40"

STEVEN MEERSON

BAYSIDE, NY

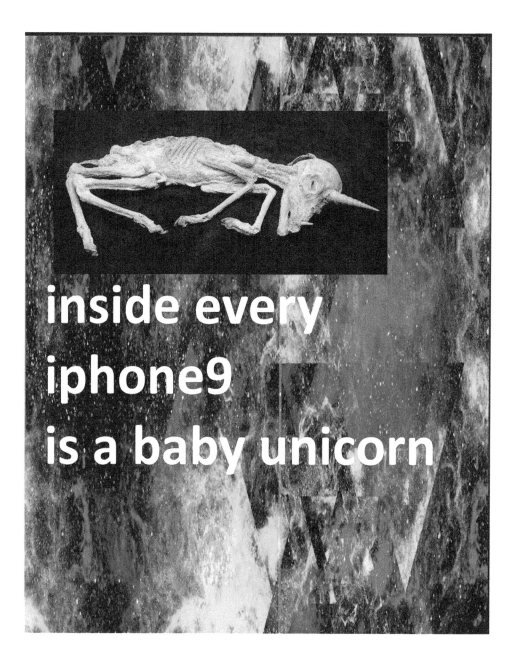

**THE EPIDEMIOLOGY OF SUICIDE IN RURAL:
A NATIONAL CASE-CONTROL PSYCHOLOGICAL AUTOPSY STUDY**

Digital collage, 4" x 5"

ZYGIMANTAS MESIJUS KUDIRKA

VINIUS, LITHUANIA

LOGOGRAPH OF ANIMALS IN SPACE

Albert II, the rhesus monkey died. Three mice died. Fourteen mice aboard the rocket Jupiter also died. Fruit flies survived. The monkey Gordo died. The monkey Yorick came back. The monkeys Able and Baker returned, but died under surgery. Two dogs and the rabbit Marfusa returned. The dogs Tsygan and Dezik survived, but died on a subsequent flight. Two frogs and twelve mice died: the rocket was destroyed during the launch. Laika died during the flight, as was intended: her return was not possible. After ten days Laika would have been poisoned with food so as not to burn alive on returning into the Earth's atmosphere. Chayka and Lisichka died. Belka and Strelka returned, and were stuffed. Pchyolka and Mushka burned to death. Chernushka returned after spending a day with mice, a guinea pig, and the wooden dummy astronaut Ivan Ivanovich. The mice Sally, Amy, and Moe returned. The dog Zvyozdochka returned. Nike gave her name to a pair of sneakers recently. Ham the Chimp returned. Enos the Chimp returned. Soviet mice, guinea pigs, and frogs returned. The French rat Hector returned. The monkeys Lapik and Multik returned. After returning from space, Dryoma the monkey was presented to Fidel Castro. The Chinese dogs Xiaobao and Shanshan survived. The French cat Felix escaped. His replacement Félicette returned. The dogs Veterok and Ugolyok returned. Two French monkeys returned. Nematodes were found still alive in the debris after the Columbia Space Shuttle disaster. American fruit flies, parasitic wasps, flour beetles, and frogspawn, along with bacteria, amoebae, plants, and fungi came back. The Argentinian rat Belisario returned. The Argentinian monkey Juan returned. The American monkey Bonny died within a day of landing. The spiders Arabella and Aranita died from dehydration. The first fish in space survived. Worms returned frozen. Newt and chicken eggs, brackish shrimp, Chinese sea pig, and Japanese quail eggs returned. The first Iranian animal launched into space returned. A Russian turtle returned, having lost weight. A female cockroach came back pregnant.

JOHN MAZZEI

SAN FRANCISCO, CA

PEOPLE PEOPLE

Photograph

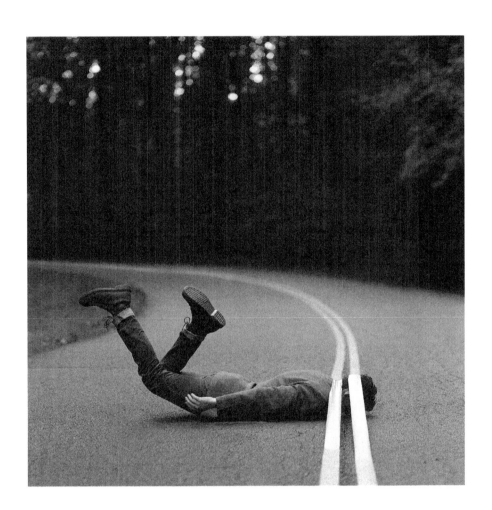

UNTITLED 355

Digital photograph 75 cm x 75 cm

HOPE KROLL

PASO ROBLES, CA

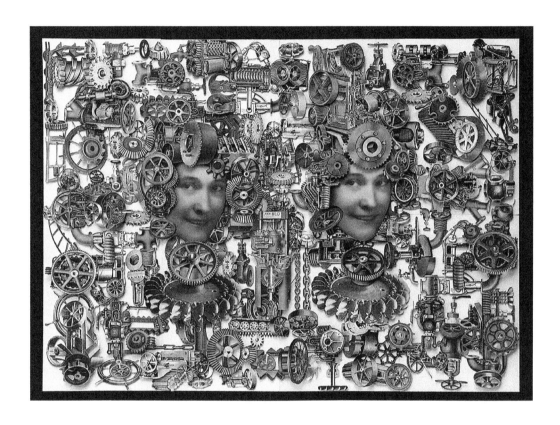

GEAR HEADS

Hand cut paper collage, 3 dimensional
33.5" x 22.5"

PATRICE LEROCHEREUIL

NEW YORK, NY

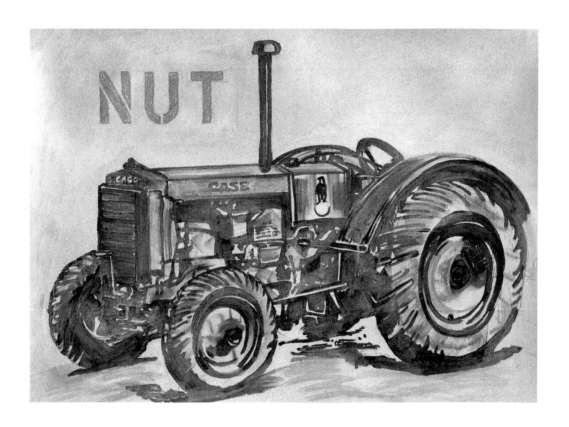

NUT CASE

Mixed media

MARA PATRICIA HERNANDEZ

ZAPOPAN, MEXICO

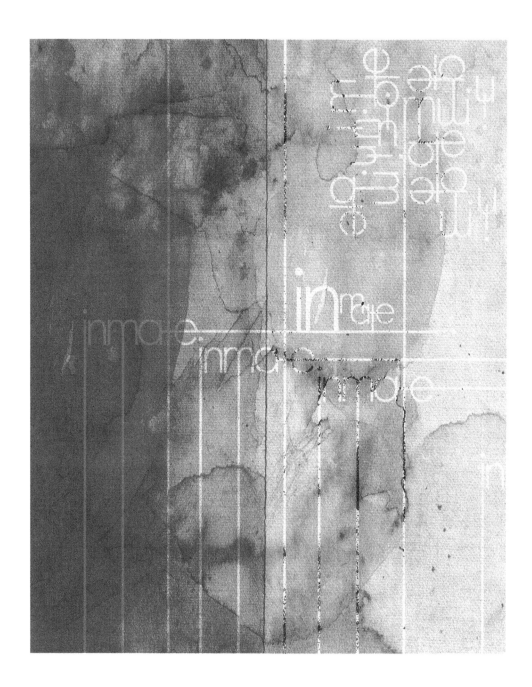

INMATE

Digital print

ALI ZNAIDI
GAFSA, TUNISIA

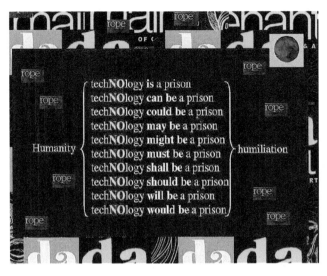

UNTITLED: A DADA VISPO
Digital collage

RAFAEL F. J. ALVARADO
LOS ANGELES, CA

DAY 697

Ex-cellmate
fighting with new cellmate

saw it coming
–don't care

some have
a lot coming

they don't realize
who they are

even after
people tell them

shit
doesn't ever
know how bad
it smells

MARY BEACH

AFTERLIFE

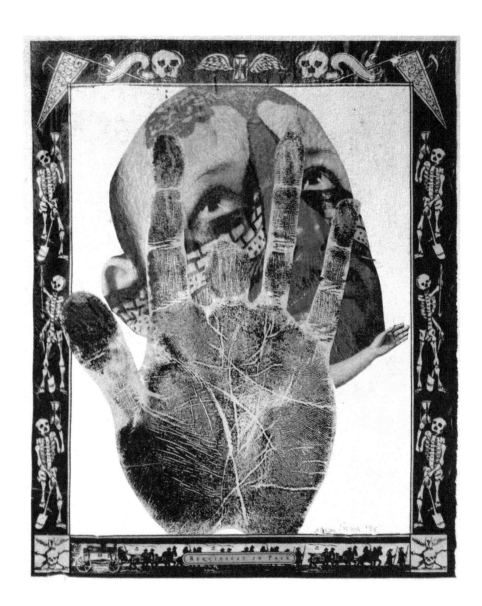

REQUIESCAT IN PACE

Collage

GRANT HART

MINNEAPOLIS, MN

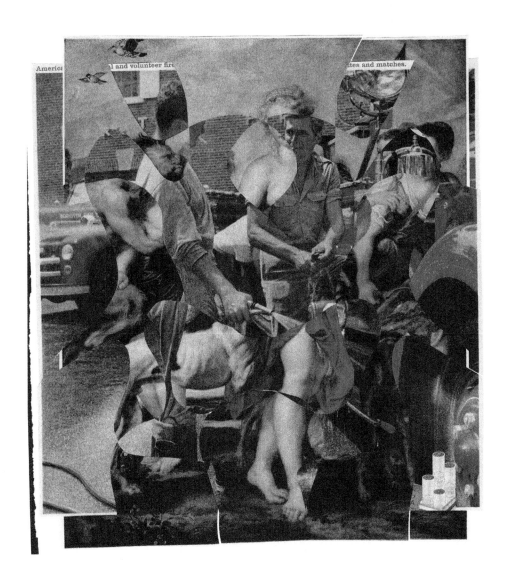

FIREMAN 2

Collage

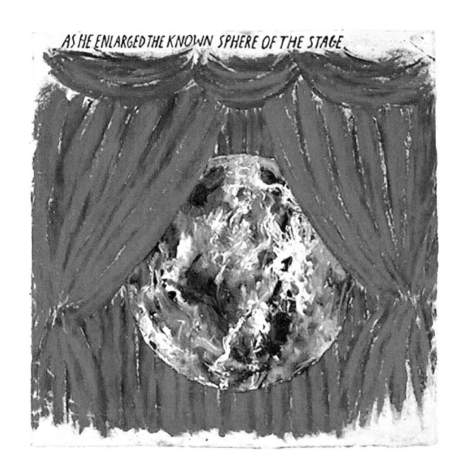

UNTITLED *(As He Enlarged. . .)*

Acrylic, gouache on paper. A collage

CHARLES PLYMELL

CHERRY VALLEY, NY

PLANET CHERNOBYL

Hiroshima, Nagasaki, Fukushima, and Chernobyl
 silent death radiation neon
 suburban ennui
They call me Dr. Faustus of the abandoned universe
I play with never-ending chain of paper dolls
your ghost
 sheets on clotheslines
 buzzing flies in strings of invisible reactors
I trade with the devil
 buy used souls and best minds
Hiroshima, Nagasaki, Fukushima, Chernobyl
tomorrow the Mississippi
 Hudson and San Andreas
 last gasp of living creatures on dying planet
blind radioactive paradise
 China to the dead Dead Sea
You'll never see me
 sub-atomic particles
black flag of time
 dead again
open the great fissures
 who abandons them
down to where the sea claws gather
The best minds of a generation split the atom
Whitman sang belonged to each
 now breathe the air again and
split the cells that spiral to instructions
 duplicate greed like
 Radioactive cancer
found the best minds in New Mexico
boys school Burroughs
 in short pants and pith helmet

chasing lizards in the sand
man creates destruction with his hands
Apache dark eyes no more
four strangers from the east on Rio Grande
A moor and three Spaniards in 16th century
now filled with energy lines & high wires
modern icons on the landscape
crown cross conquistadors forevermore
scientists smash particles like angry kids at play
and the devil opens prison door
knows the price of soul and drugs
in white lab coats Frisbees throw
and know equations of
the abandoned planet of catastrophe
in the zone of no choice
nothing but hands
and in the sea
dolphins with the brains.
Soldier, liquidator, criminal minds
when karma of coyote piss is bottled for perfume
vodka is made of bleach & kerosene & keeps
the skin from sticking to the pillows at night in Belarus
darkness comes over the game of win against whom
the atom of physics or the universe of nothing
in the stadium of the mind
A self-replicating medal to pin upon them
trees scared too but quiet as a meltdown
ancient bones Scorpion bombs
genetic jails full of fear
prison consciousness collides with larger culture
civilizations smash like particle accelerator
virtual mutant gene pools rising like tsunami
hand around planet breaks its beads.

Tear down Kentucky mountains and fill the seas
with garbage real basic real fast fate of species
creating ourselves techno-robots with our hands
no fear of death, comes with price
 no war, no savior.
 Acuras and Cadillac gasoline
 spent radon forever
 petrified creature museums
back to die of shock when daylight breaks the hourglass
drums dream of nuclear fires on wretched soil
already mystery of different people's disease
who know how to live in terror as a natural habitat
planet plugged with scraps of clothing, bones,
concrete, books, newspapers, stolen skates, dying birds
and the streets change without notice into
black sky nuke drugstore cures
 and special Olympics.

 in the shadows of good and evil hydra hearts
and hands that built the world of energy splitting
 secrets that pushed buttons for generations
 looking for something familiar
to hear someone say we'll win
 ask the voices from
Chernobyl with radioactive foam on their lips
Vodka eyes listening to beeps and silent clicks
biggest killer medal of all
 galvanized skin radiation rising award
Hiroshima, Nagasaki, Fukushima, and Chernobyl
while neurotoxins fades old glory gold
seagulls in the sky beneath moon time & space
blinded in self-replication river of blood.

Chernobyl dosimeter and guns of hunter
liquidators animals crying looking in the eyes
of humans who control their fate again and again
one government with the gun of nuclear power and
military secrets national energy secrets arm sales
in a pact and prayer of old incantations of nowhere.

Gazing into eternities of toxic sunsets wiped clear
sulphur settles in place where skin sheds the leper
on last rock hot on the inside and
cold on the out where it all began to lay waste
in the name of power and physics new childhood maladies
while last punk band plays to one million raised hands
COATTAIL JESUS AND HIS HOUNDS OF HEAVEN.

In every eye the universe in every creature the eye
the machine entangles animal life and time loud as
blasts that blow breaths into the bagels of outdoor coffee shops
black skies not far away fire falls beyond the razor-edge fences
of those who go to bed alone
and the fish in the sea finally have
the blood of reality
compost of radioactivity
mountains of poison topped to bury earth in the earth
and stream under stream
from pulsar stars at the edge of time
coal fire bigger than mountains of eternity
the event of the unknowable psyche
where they all came to see the faded dolls

wearing the bling of perpetual self
until econoline van brings body & soul of love
erupting in a plume delivered in right time and space
the bird's song unheard by human occupancy
Sappho's distant cry when her bird died is heard
the island child continuing in toil and hunger for life
Egyptian blood spills into sand of thousands of years
geiger chatter replacing chants & songs of revolutions
carbon & crystal separate at undecipherable boundaries
of the dream alone in flight fascinated and frightened
like shy animus that escaped the sale to the devil
living for hundreds of thousands of years
under the sarcophagus-like silent waters of the Hudson
we breath silent radioactive dust or PCBs
urge to purge and puke through trash of cancer cells
last change of clothing where senators of gluttony
gaze to rape classmate they sat next to in school
and gnarl and rasp and grate and scratch rotten skin
doomed like innocent creatures in feed lots of television's
empty insane tube where lost computer chips
explode into cosmic dust forever detected cells
in blood of hard mud pies lung and liver pouring
from the mouths of blind throne empires last lamps
shining like moonlight over the radiant seal's back.
Mr. Nuke, Dr. Devil, Mephistopheles, Christ O Mighty,
Messier Split of radioactive coffins in Isotope Russia
Japan and half-life America the material toxin pile.
Beyond the Federal Zone and nuclear wash
hanging forever clotheslines of plutonium
panties from eternity's wash, torn lace of
consciousness captured in a crystal lattice
Animals dying from lack of love and care.

They are hungry and sick with radiation
liquidators shoot them like collateral bodies
under the breath of silent clicks of radioactive dust
that formed the brains of battlefields forever war
under their gods who comfort devil's wealth
can hold out to the last person but try to escape
like the poached elephant dead, only predator man
its baby won't leave but dies of love trauma unseen
in Africa unheard as the prayers to escape nature
beyond Japan, beyond San Andreas, the Hudson,
the great Missouri rolls on like the lesson of Russia
Wars were nothing and now the real terror begins
in racial senescence of each breath & memory of the
apocalypse arriving in increments, look around you.

ANNA MARIA DRUTZEL

VICTORIA, AUSTRALIA

WORMHOLE

ash gray – azure blue

eyes, like butterflies

flitter upon

their own reflection

casting clouded shadow

against infinite

contractions of

the word – misery

sometimes, humanness surfaces

a word, a mouth attached, a subtle

gesture – peeling back

the falsehoods of a wormhole

here, fingertips surrender

what rightfully belongs to

the heart – in a void

where man makes god

the lesser creature

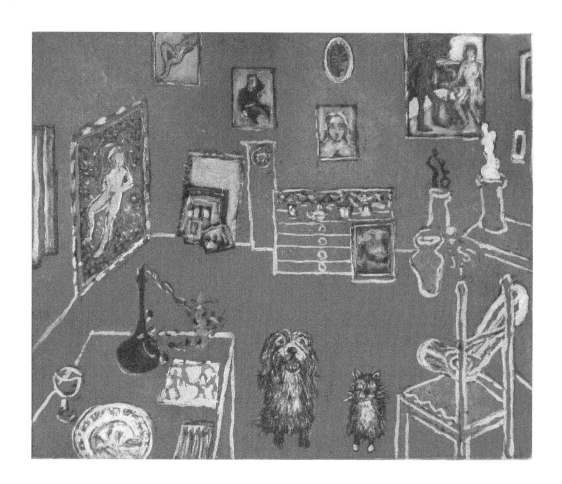

RED ROOM WITH DOG & CAT

Painting

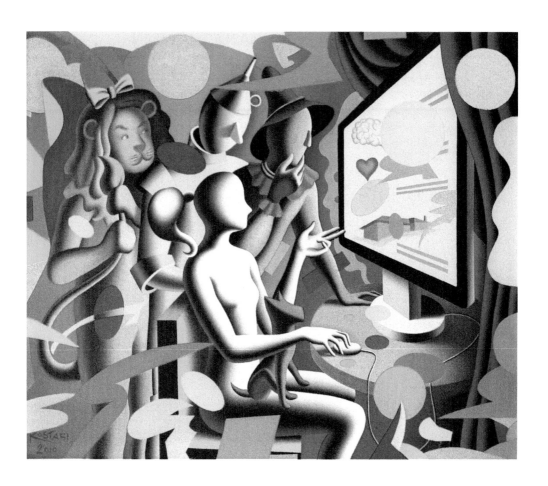

CLICK ON THE YELLOW BRICK ROAD

2010–2015, 50 cm x 60 cm

JOEL ALLEGRETTI
FORT LEE, NJ

ENGINES MORE REASONABLE THAN MEN

The title phrase appears in Stanislav Filko's "Associations XXVIII," a list of imagined milestones collectively called "The Future Exploration of the Universe, According to scientists [*sic*]." "Engines more reasonable than men" is a prediction for 2080.

MONDAY

They spend the day pledging their commitment to a balanced budget.

TUESDAY

Reiterating the pledge, they begin.

WEDNESDAY

They congratulate themselves on their dedication and progress.
Work resumes.

THURSDAY

Work continues.

FRIDAY

They achieve a balanced budget.
Acknowledging their obsolescence, they shut down for good.

SATURDAY

They are removed and replaced in preparation for the coming week's agenda.

RABYN BLAKE

TOPANGA, CA

"LILIES OF THE NILE, NEFERTITI"

But consider: Man's desire to replicate himself throughout time in the form of homunculi, gnomes, fairies, cherubs is mythic. Now it is the "joy of man's desiring" to imagine eternal life for himself. As Nature may come to be unable to provide for fruition, there is the dour implication that life may come from the laboratory. Could this be benevolent compensation for a depleted Nature? Desirable qualities to enhance planetary life—Love, Beauty, and Compassion—might come to pass.

Porcelain, floss, parchment, in lucite laboratory tissue culture chamber. 9" x 12"

TITO MOURAZ

CANAS DE SENHORIM, PORTUGAL

UNTITLED (Project: "Finally, No One")
Photograph

MIKE WATT

SAN PEDRO, CA

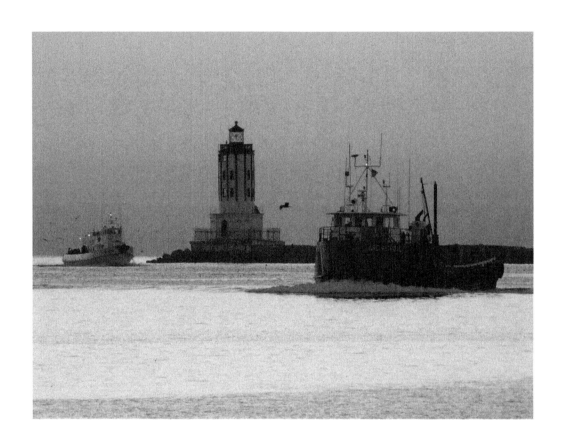

SUNRISE IN PEDRO

Photograph

POUL WEILE

BERLIN, GERMANY

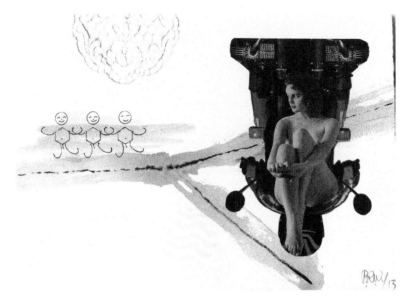

WHEN A SAILOR GOES ASHORE

Misc. on Hahnemühle paper, 28 cm x 40 cm

PUMA PERL

NEW YORK, NY

LADY IMMACULATE

The world is filled
Symbols, screens

But you,
 my immaculate stranger,
 remain unblemished,
 a smooth black leather
 mystery, flawless
 in the earth's rotation

Night saves me
Morning kills me

Your pristine
perfection crashes

My Beauty,
lost forever
in the hard
drive

DOMINIQUE VINCIGUERRA

PARIS, FRANCE

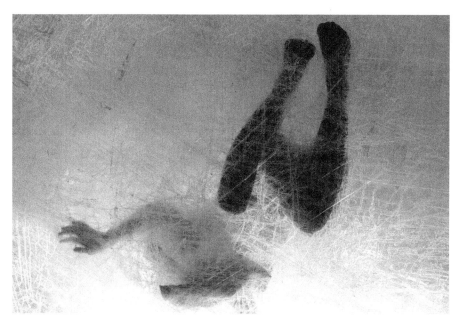

PRISONER

JPEG image, 4805 px x 3198 px

KAREN HILDEBRAND

BROOKLYN, NY

FLAME

#Sonyhack #Worm.Win32.Flame #cyberPearlHarbor #malware #crediblethreat #surrender

To detect and remove this threat, melt 2 T butter with 3 T brown sugar, zest of 1 orange and one vanilla bean split lengthwise. Cook, stirring until sugar caramelizes, about 5 min.

Remove from heat, stir in 1/4 cup brandy, juice of 1 orange and a pinch of salt. Return skillet to medium heat, add 3 ripe bananas peeled and halved lengthwise and crosswise, cut-side down. Cook until golden, 1–2 minutes. Remove and arrange in dessert bowls.

Add 1/2 cup dark rum and warm without stirring. Hold a match near the sauce to ignite. Spoon flaming sauce over bananas. Note: Use extreme caution when igniting cyberwarfare.

#BananasFlambe Follow us on Twitter

DEREK ADAMS

SUFFOLK, UK

ERROR 404

The host
you are trying to contact
may not exist.
The host does exist,
but the file
you are asking for doesn't.
The host does exist,
but only as an alias (or additional A record)
for another host.
Try examining the reverse DNS
for the host you are trying to reach, and
if the reverse lookup
yields a different host name,
try that one instead.
The host does exist,
but you are trying to refer
to it by IP address
rather than host name.
Use the host name
instead
of the IP address.

BARA JICHOVA

NEW YORK, NY

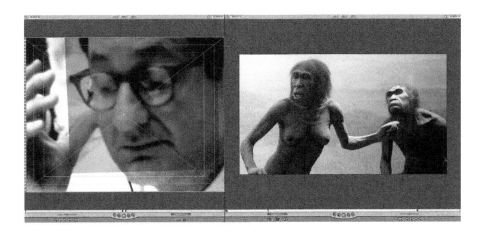

MY NEIGHBORS

Digital c-print, 16" x 20"

TOMOMI ADACHI

BERLIN, GERMANY

白白白白白白白白
黒黒黒黒黒黒黒　黒
赤　赤赤赤赤　赤赤
　青青青青　青青青
黄黄黄黄　黄黄黄
緑緑緑　緑緑緑　緑
紫紫　紫紫紫　紫紫
紅　紅紅紅　紅紅紅
紺紺紺　紺紺紺紺

colors you have not seen.

**THIS (7507 C) TITLE (PMS332) IS (5285 C) USING (612)
PANTONE (7549) NUMBERS. (182)**

Colored text

GINNY LLOYD

JUPITER, FL

PINK MAZE

Computer graphic, 5" x 3.58"

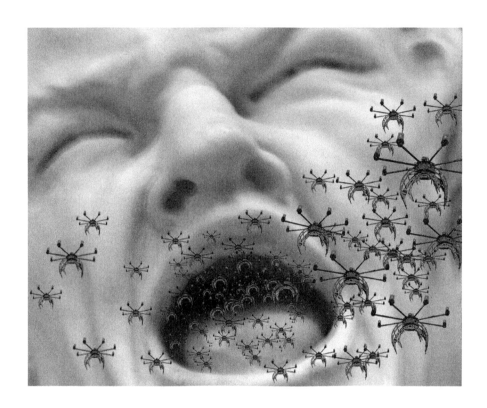

THE LANGUAGE OF LOVE PART I

Digital photo collage, 4" x 5"

MARK BLICKLEY

LONG ISLAND CITY, NY

No no Baby I love you adore you love you worship you not as a jealous obsessive but as a romantic who misses you so much that when you sleep and your velvet voice is silent except for light snores and occasional pseudo-sexual groans from dreams that I know are about me I feel compelled with passion to go through your phone and read your texts not because I fear you are cheating on me or interested in other men but simply because I ache for the beautiful words that flow from your mouth words of love desire and heartfelt denials of infidelity that cause me to enter a cyber lust to see and feel the sweet language your electromagnetic waves echo out into that mysterious void to recipients other than myself in soft disembodied language that so easily light up a cellphone or tablet in imitation of how they light up my aching soul no no Baby I'm not spying on you or stalking you like some suspicious cyber creep I love you truly love you and am not an insecure untrusting possessive overweight wanna be alpha male droning on about how grateful you should be that someone like me has allowed you to reside not only within his deepest purest feelings but also rent free within the loveliest duplex apartment on this Upper East Side of Paradise because I genuinely and honestly love and trust you Baby. . . .

THE LANGUAGE OF LOVE PART II

Text

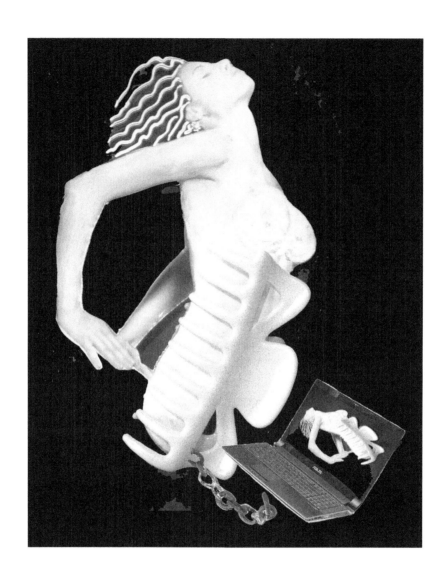

CATENE TECNOLOGICHE

Collage

PERE SOUSA

BARCELONA, SPAIN

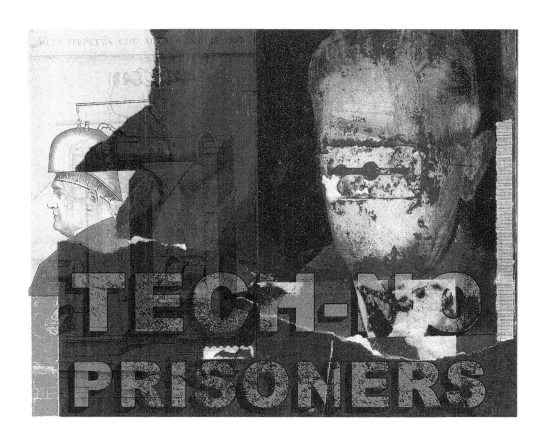

NEW MAN

Collage, 5" x 3.847"

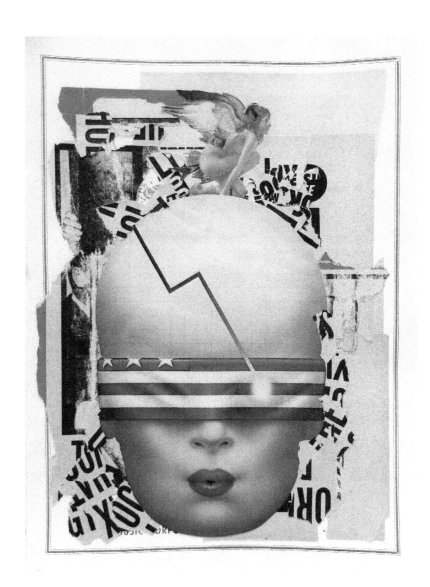

SPYBORGS

Paper collage on vintage songfolio cover, 9"x 12"

NINA ZIVANCEVIC

PARIS, FRANCE

THE AMERICAN EMBASSY

Oh! To be locked up in a building

With shiftless faces

Who serve those who think

That they rule the world!

And yet! The toilets in

The building were so pretty—

I wish I could've kept

My "green card" just so that

I could flash it in passing by

And enter the embassy quickly,

Use one of these "de luxe" blue toilets

At times when I happen to be in a hurry

At times when I am in this "Concord" area

To which Concordia has turned her back,

Ruined the old French–American friendship

And has left for more spacious fields.

WILLIAM A. SEATON

GOSHEN, NY

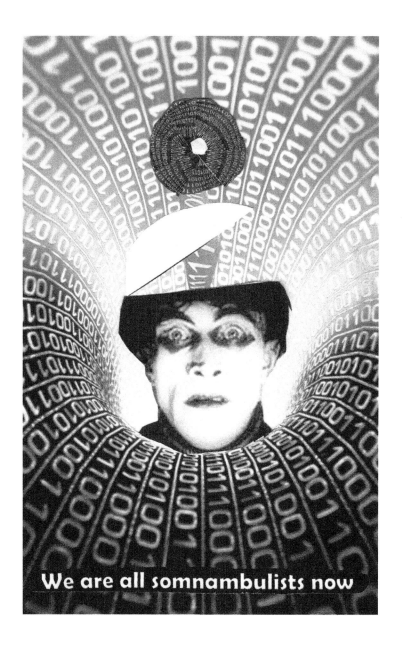

WE ARE ALL SOMNAMBULISTS NOW

Collage of paper printed with Internet images, 5.5" x 8.5"

GERARD SARNAT

REDONDO BEACH, CA

LIBRE DE VIRUS

dear son, thanks for visiting last week.

it would be a godsend if i could be dead

but i'll keep my word.

The haitian woman who takes care of me

offered to answer an email from a young man

from the rbc trust.

she said he managed dad's banknotes,

fifty million united states dollars ($50,000,000)

and i should share 1% with him.

would you believe we're rich!

love-dovey air kiss, xo, mom.

ps, do you know where my wedding rings went?

ROBERT GIBBONS

BROOKLYN, NY

SEARCH FOR A DEFINITION

insert a knife back into the dictionary

so I can clean cut my heart out

then give them a ventricle, an aorta

view this deep cut on my wrist

the twist of emotion,

insert and desert this space left

like Duchamp's bicycle wheel

the lost one from 1913, before

the war, after the war, after

the flesh has burned, will never be

surreal, only real.

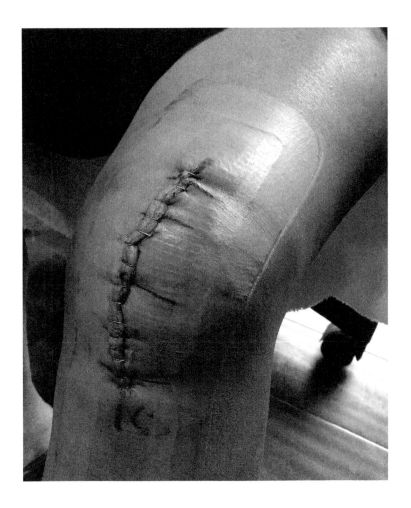

BRAND NEW KNEE

Photo: Greg Velasquez; Model: Alice Bag

ROKUDENASHIKO (MEGUMI IGARASHI)

TOKYO, JAPAN

SENJO-MAN / BATTLEFIELD-MANKO

Cell phone cover, mixed media, 17 cm x 9 cm x 8 cm

Editors' Note: Japanese artist Megumi Igarashi, who calls herself Rokudenashiko, has been arrested twice (July 2014 and December 2014) on obscenity charges related to her use of images, data files, molds, and 3D prints of her vagina in her artwork. The above cell phone cover, for example, is decorated with a 3D print of her vagina, and other media. In the background is a kayak which was formed from an enlarged 3D cast of her vagina. According to an April 15, 2015 article in The Guardian, "She is accused of distributing data to people in return for donations to the crowd funding kayak project. The recipients could use the data to print 3D images of her genitalia." As we go to print, her trial has begun in Tokyo. If found guilty, she faces up to two years in prison or a maximum fine of 2.5m yen (£14,200) for distributing obscene objects. "I do not dispute the facts [of the charge], but my artwork is not obscene," Igarashi said, according to a local news agency.

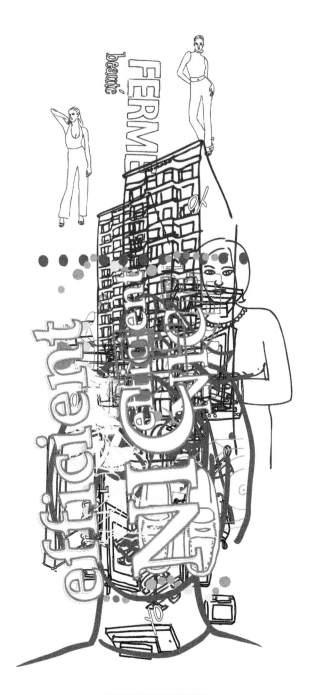

NICE/EFFICIENT

Digital print, 26 cm x 45 cm

GABRIEL DON

NEW YORK, NY

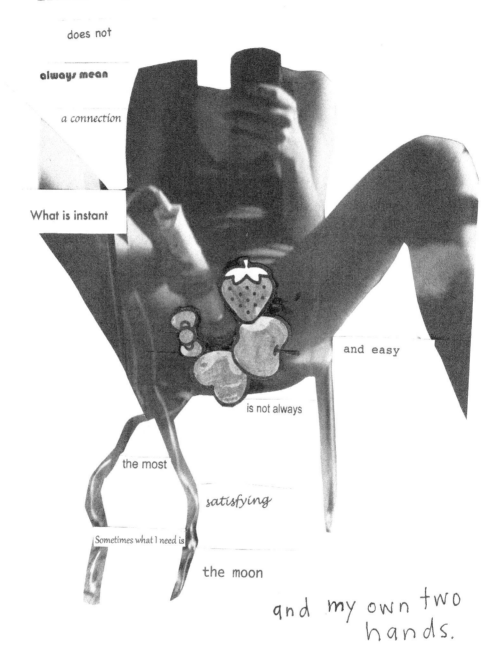

Electricity

does not

always mean

a connection

What is instant

and easy

is not always

the most

satisfying

Sometimes what I need is

the moon

and my own two hands.

ELECTRICITY

Poetry, collage, photography, and watercolor

NICO VASSILAKIS

BRONX, NY

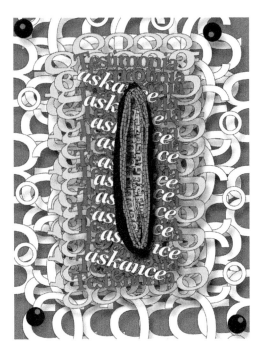

TESTIMONIA

Digital illustration

DEBRA JENKS

NEW YORK, NY

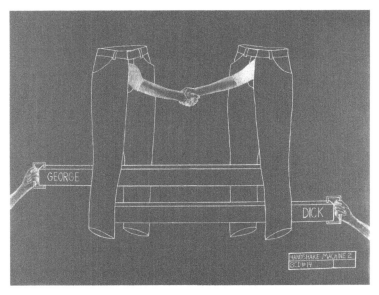

HANDSHAKE MACHINE 2

Pen on paper transferred to blueprint

JANE ORMEROD

NEW YORK, NY

FAILURE TO UNDERSTAND

The contents page in this book is wrong
The contents are incorrect
These authors cannot be found
Their words found dysfunctional
Their pictures erased
"So these writers are imposters," you chime
No!
You, the reader, are the imposter
These pages are not contained
And certainly not contented

GEORGE WALLACE

HUNTINGTON, NY

ONLINE DATING

misery fishes through the dumpster looking for
company. i'm available but can't get misery's
attention. "choose me choose me," i yell,
between two egg crates and a butt of ham.
"i'm miserable too!" no use—the glue won't
stick. misery is a contented lobster, crawls off
with some other prey.

a mob of reporters with an appetite for scandal
closes in.

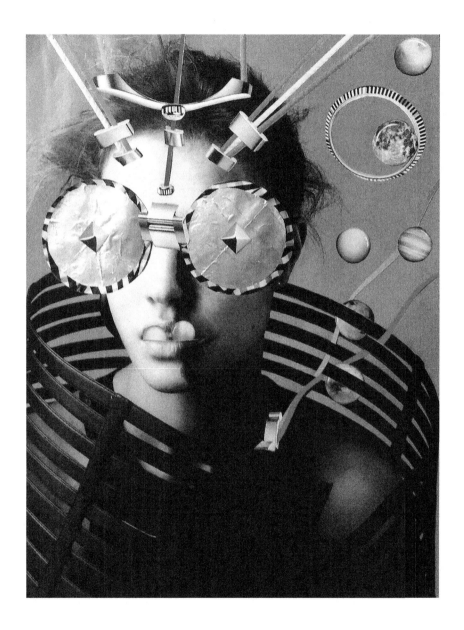

CONNECTED GIRL

Paper, 22 cm x 29 cm

ALFONSO IANDIORIO

NEW YORK, NY

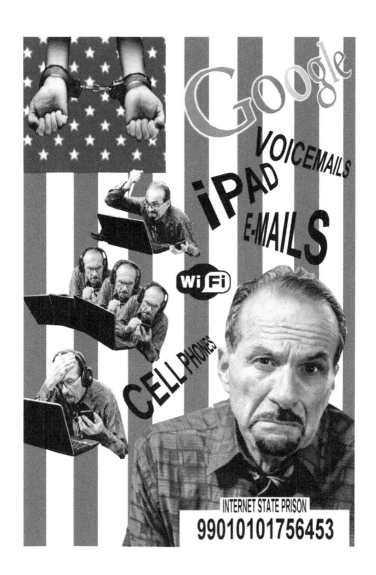

DIGITAL DESIDERATA

Collage

LOIS KAGAN MINGUS

NEW YORK, NY

Sucked into a need with no escape,

lucked into a speed, conspiring with staggering magic,

I drool, I punch, I bang my head.

I gotta do this, no choice, no choice.

I need you like a red-hot lover.

You make me come, invigorating my senses.

Plugged or unplugged, I'm handcuffed to you.

The top of my lap grows, spitting goo and satiety.

Who needs humans when pressing keys satisfies.

I pledge my allegiance, there's no going back.

We're here together, safe in our perpetual prison.

DIGITAL DESIDERATA

Text

DAVID LAWTON
NEW YORK, NY

AUTOMATA

If you're okay

> Being part

Of a machine

> That's your bag

No skin off my butt

A machine

> Gets things done

> > Like Mussolini's

> > > Choo choos

> > > > The problem

> > > Isn't the machine

> > It's the weevils

> That get into

The machine.

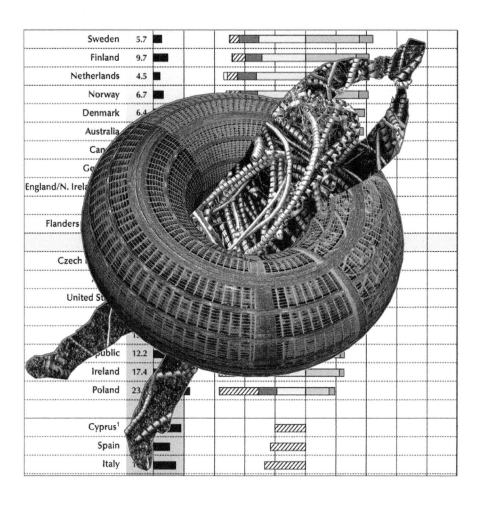

BEST BATCH YET (NOW 1)

Collage

ANN FIRESTONE UNGAR

NEW YORK, NY

http://

http://sawbladesofthetechdaywithits*brain
drainscrambledbrainbraisedbraincellloss-
pathwaysgainedinamomentofclarity-aren'tw
orthmuchcomparedtoajokeormother'smilk-
ITisfullofsaintsscaredthemselves-respondingtoyourproble
mwith"That'sinteresting"-thenforeseeing-patching-solving-
lookingitup-fortheUser, strungoutondocumentsfordollars-
freefallingthroughcyberspace-aclickinthepressofhightechd
esperation*inthosemomentsitseemswemaynevermeetagainf
oradrink-abagofchips-orafinerisottowithEnglishpeas

DYLAN NYOUKIS

EAST SUSSEX, UK

BRAIN DRAIN

Digital image

KAREN CONSTANCE

EAST SUSSEX, UK

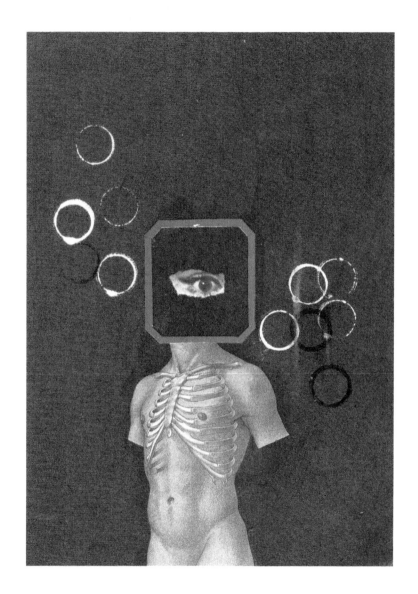

UNTITLED 1

Collage on canvas, 12" x 9.8"

RICHARD MODIANO

VENICE, CA

Peace Plaza, Hiroshima
Japan, August 6 2005
The time: 10 minutes
past 8 in the morning—
 In exactly 5
minutes a bell will toll
to mark the moment
when the atomic bomb
exploded here—
 8:10 and it's already
90 degrees—5 minutes
from now and 60 years
ago it was 10,000 degrees
in Peace Plaza, ground
zero, the hypocenter
—and here I sit in a
folding chair with 500
other people on this
spot 1,500 feet beneath
the detonation point,
looking at the empty rostrum—
Past the dais I can see
the iconic A-bomb-racked
building left standing, and
the white cenotaph where
scores of unknown bodies
reduced to ashes lay—
To the right of the
dais sit the big shots, Koizumi the PM,
the government officials
from Europe, Russia, even
from the PRC and the ROK, victims
of Japan's aggression—
Where are the Americans?
Sitting with the rank & file,
all us peaceniks, Buddhists,
Methodists, Quakers—no official
acknowledgement from the US
government—maybe
for the best—
 The bell is tolling
8:15 AM—the sun's
exploding—

Editors' notes:
Koizumi: Junichiro Koizumi,
Prime Minister of Japan
2001–2008. PRC: People's
Republic of China. ROK:
Republic of Korea.

JOHN BOWMAN

NEW YORK, NY

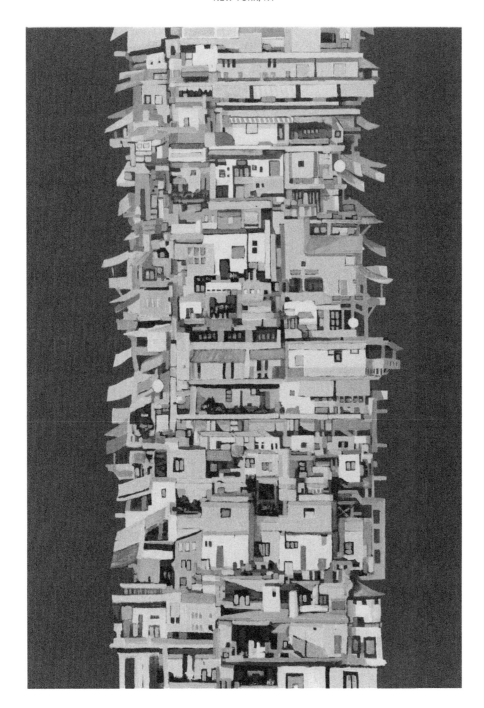

TOWER

Oil and acrylic on canvas, 52" x 30"

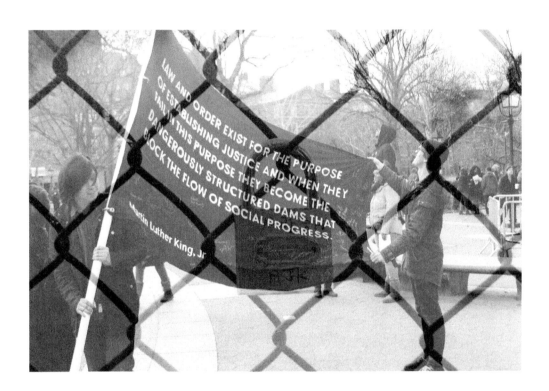

EXORDIUM

Digital photograph

HAMZA ABU AYYASH

RAMALLAH WEST BANK, PALESTINE

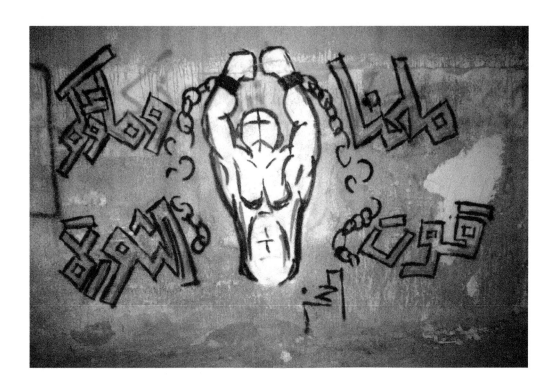

OUR SALT AND YOUR WATER IS THE FOOD OF REVOLUTION

Spray paint on concrete wall

PETER CARLAFTES & KAT GEORGES

NEW YORK, NY

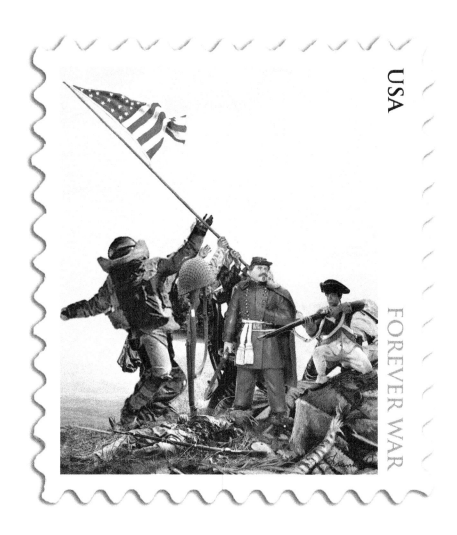

USA

FOREVER WAR

FOREVER WAR STAMP

Digital collage

PHILLP MEERSMAN

BRUSSELS, BELGIUM

CARDINAL POINTS

(4Kat —and also 4Peter)

Four is the number of corners on a standard page

Four is the number of sides on a standard page

In the middle of these sides—halfway between the corners—

Cardinal Points are marked

To the north—a bearded redhead recites *Beowulf* with a castrate—there is no sun

To the east—a rusalka analizes Tambov poetry using Tartu semiotics—the moon rises like blood

To the south—an elephant searches his Hannibal to cross pink alpine peaks—the heat scorches the page

To the west—the water of the ocean deepens with every Kon-Tiki trying to catch up with the Galician, the Painted and the Niña—the sea sets into the broadening sky

Four is the number of triangles appearing when connecting the corners on a standard page

Four is the number of rectangles appearing when connecting the cardinal points on a standard page

Four is the number of ways a standard page can be folded in two

Three is the number of parts one folds a letter to fit into an "American envelope"

Two is the number of editors to work on the book

One is the number of poets writing the book (without taking into account the amount of poets inspiring the poet writing the book)

Zero is the number of days until

VOLODYMYR BILYK

OBLAST, UKRAINE

recall
cancelled
national preparedness .

exercise
sick | emergency | lockdown | .

plot
failure | to | help
and | storm | in | response | .

and | then
brown out
the | crest | of | incident | .

EffErvEscE

Word poem

PAL CSABA

BUDAPEST, HUNGARY

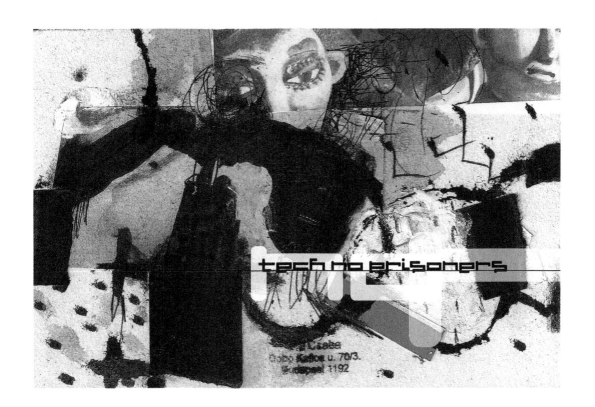

TECH-NO PRISONERS

Painting/collage

HANZ L. DAIKEN

LOS ANGELES, CA

YIN YANG

Acrylic on canvas, 18" x 24"

LEE WILLIAMS

NEW YORK, NY

ABOUT THE CLOSING OF CBGBs

Hey necktie face
Nowhere man
Yeah you—
plastic bag in a tree

You
SPIT

Nazi Punk Fuck Off

You say:
"I want downtown
I want view
I want luxury
I want service"

But you can't buy
cool with your
2 million dollars

Nazi Punk Fuck OFF

DOUG KNOTT

LOS ANGELES, CA

MY MOTHER THE E TRAIN

On the yellow-stripe platform,
Attention sucked by sharp bright light
People clench butt-muscles
Grip bags, turn up-track like
meerkats for the familiar stranger
with the roar that jiggles flesh

Stand up for the E train!
Stand up for the might of door.
This sandworm with
the same steel mouth at both ends
can eat through formerly secure island granite
with the speed of pornography

Up there on 5th Avenue, there's
Concrete and hypocrisy, plus
Delight in shop windows.
The real weight of all that concrete
Is both finite and infinite.
Rich people are holding up banks
People walk with umbrellas pitched against cloud and rain
Water towers stagger on roofs

We're just a wriggle in the terrarium
Reeling around the West Side,
My buttocks slam against the wall, and
I celebrate humility, efficiency, electricity
Survival and abuse, and in this car
Enjoy the migration of other urban birds—
Namely the decrepit, the one-legged, the wool-capped
The glamorous, the highly-pressed
And all those who have sex inside their suits
Up-river in the spawning grounds, or
Downtown towards the sea of birth

That girl looks thoughtful
Between earphones like teardrops—
She's going to eat her phone!
I want to see her mouth open silver and red
And the metal stop talking

Stand up for Spring Street—what spring is that?
Expulsion into cold dull day
Tourniquet of noon.

Threading pedestrians, I
Walk fast as a winter riddle,
But it's only for a lunch with a friend—
a pasta restaurant with floppy noodles
in an all-eyes city
Which is itself a restless hunter,
And I got here invisibly
Because nobody that saw me
saw me

LINDA LERNER

BROOKLYN, NY

42ND STREET ON A SATURDAY NIGHT

Corralled off sidewalks onto streets
beneath the technological fallout of flashing
 billboards
everyone is breaking down digital. . . .

the man I am with has vanished into his watch
his eyes force down the watch hands
it is 7:45, we have 15 minutes to get there
what is wrong with me he says without speaking

the crowd thickens, feels like dust
blowing in my face, and how we move
isn't like walking feels like riding on horses,
I tell him this without speaking, riding slow so slow
he looks at me as if I'm crazy

a slow motion stampede of people
riding thru every color of sound
thru the flash of gunshot speeding lights

do you hear it do you see
we've been flung back in time
I tell him with my eyes body turning
up down everywhere but

he is too far into his watch to hear me . . .
It is one minute to eight; a huge billboard
drops down before us
we are standing in front of a theater
I don't know if it's real or if the man who
now steps out of his watch is

real is what he wants to see
forcing me there even if it's not where we are

NATASHA ADAMS

PERTH, AUSTRAILIA

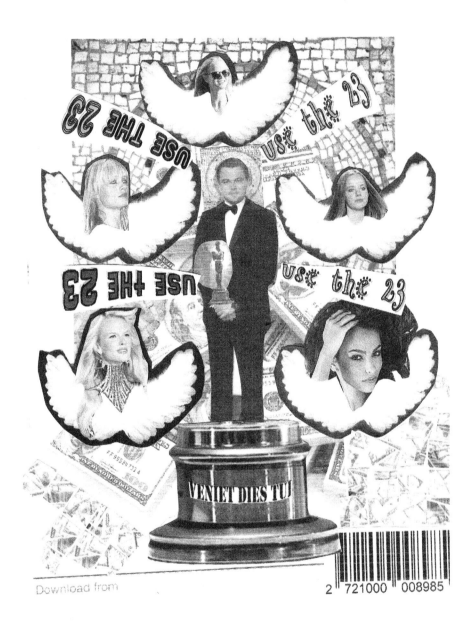

c3l3br!ty

Paper collage, A4

MARTIN H. LEVISON

FOREST HILLS, NY

NSA SPYING

Who died and made you Pope, God, Christ, Caesar, chairman of the board, pharaoh, caliph, sahib, khan, president of the United States, CEO of Facebook, head of the Fed, apo di tutti capi, Captain Crunch, major domo, chief commandant, presiding officer, numero uno, dictator, autocrat, hierarch, honcho, fuehrer, doyen, dean, exec, overseer, prolocutor, point person, padrone, potentate, guru, governor, gang master, band master, ring master, straw boss, standard-bearer, skipper, sovereign, superintendent, sachem, seigneur, supremo, mogul, magnate, magistrate, mayor, managing director, commissar, cock of the walk, chieftain, commander, warden, grand poobah, master of the universe, omnipotent OZ, Roger Maharajah, viceroy of vichyssoise, lord high executioner, knight of the round table, His Royal Majesty, big cheese, big wig, big fish, big bwana, big brother, big bopper, big kahuna, top dog, top banana, Boss Tweed, Commodore Vanderbilt, sultan es selatin, negusa negest, ayatollah, Archduke of Canterbury, Cardinal Richelieu, Napoleon, Count of Monte Cristo, the Great Gatsby, Kaiser Wilhelm, Generalissimo Franco, Field Marshal Rommel, Emperador of Spain, Shah of Iran. Czar of wherever you are, Baron of the blues, Emperor of empty promises, Prince of persiflage, ruler of my heart, driver of my soul, leader of the pack, king of rock and roll, the duke of Earl, and the guy who reads my email.

HENRIK AESHNA & JEAN JACQUES LEBEL

PARIS, FRANCE

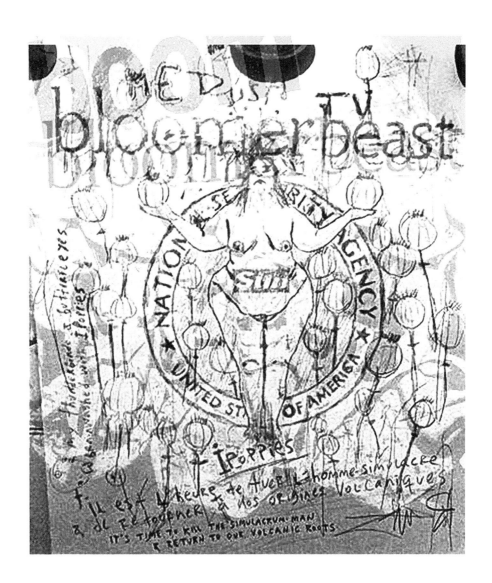

**BLOOMERBEAST (IT'S TIME TO KILL THE SIMULACRUM-MAN
& RETURN TO OUR VOLCANIC ROOTS)**

Drawing/collage/dialog

W. K. STRATTON

ROUND ROCK, TX

PROSE POEM VI

Flash this selfie and the Cowboy Kid glares back. Your reformat has failed. Corrupted files abound in those pixels staring back at you, no disk swipe here. Click and remnants of nights spent beneath a relay tower, a face fresh-soaped yet already spent, listening to Buck Owens and Black Sabbath. Tap and recollections of the Let 'R Buck Room in Pendleton scroll endlessly. Tap again and tears of four hundred women stream from a waterproof case—$37 extra. Error reports on red dirt wrecks, mescaline bending trees and stars and fence posts into one thing. Explain the logic. Here is a recovered spreadsheet of Disciples of Christ training, Reverend Harry Hembree, honest and harmless, attempting to shine a light against fake wood paneling. Paul & Silas bound in jail, all night long. Here is Father Joe Thompson texting Nixon mendacity. But nothing posts. Instead here is a vid of Bud Lilly's Trout Shop, back when Bud himself provided basement instruction, the right bend of the wrist, nymph later laid out on the snow-melt brown Yellowstone, a strike, and your first trout logic poem. True religion here. True religion newspaper .jpg of Hank Williams' last Lovesick yodel—Skyline Club, December 1952, Austin, Texas, the Drifter a corpse made up for the public viewing, no light behind those eyes, voice holy. True religion—the Skunks at CBGB's or Raul's. Google it and up pops Charles Plymell's headliner photo of Neal Cassady and Ann Murphy. Youtube Hank Snow singing "Movin' On." All of Jimmie Rodgers. Ma Rainey's deep blues moan, Little Willie John and "You Hurt Me." The Father, Son, and Merle Haggard of it all—the Gospel according to St. Thomas and Lightnin' Hopkins. The hard drive failed when you attempted to webcam God above the sacred mud of Blind Willie Johnson in Beaumont. Recovered it reveals only Cowboy Don though, beatified virus, sprinkled and spring-loaded with the Holy Lone Star, end without world, cite this creed. The Cowboy Kid— Cowboy Don's digital service pack—loops on.

CLAUDE PELIEU

AFTERLIFE

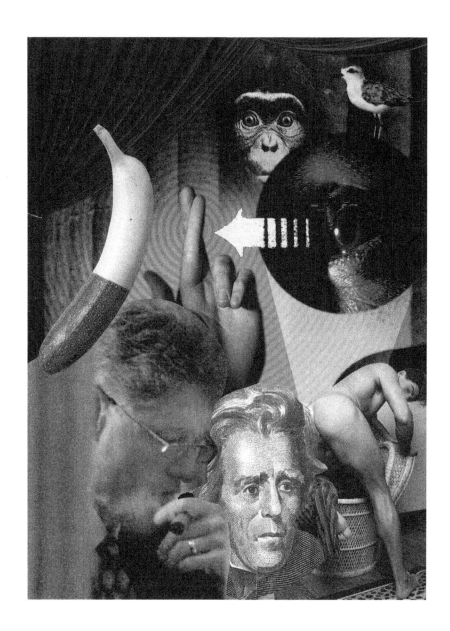

CLINTON

Collage

HILLARY DIANE RODHAM CLINTON

Pigment ink print, 16" x 20"

photo by urayoán noel designed by @johngpriest

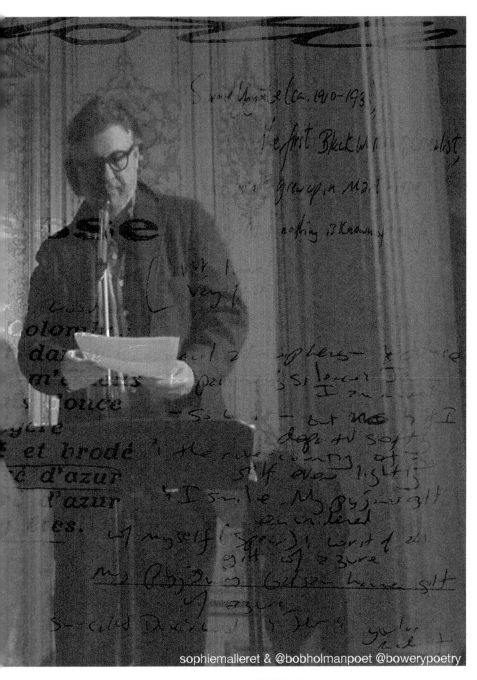

YOYOTTE

Treated digital photo

A VERY BRIEF MEETING

But that's been their response and I spoke to them but it's only Jeffrey who objects and it was only a very brief meeting and it was excellent a very good meeting but I do have to look at the material actually so I'll phone and we'll catch up later

Yeah yeah yeah yeah

She wanted something to back up her ideas yeah no definitely it was recommended but also with the coding as well surely there are reservations with all of them

Brilliant OK
No no no no

One thing that I do think as well is in terms of trying to create a model for staff I think she really needs to work on it I think we're both you know with the Oracy and the Creative you know we could have with support they could become role models and they would be keen to put the time in and it would be someone with the drive that they mean they could do it but I really think that he would find it hard to juggle it but no I didn't say anything I didn't say that no I would never bring someone's personal life into it but he's on a learning curve now in terms of his own development and this is an opportunity for us to do that and also on the positive side of things we've given him two things but that doesn't mean that in two weeks time something else doesn't come up when he's more ready more settled.

AT CIRCULUS VITOSIS

Photograph

BE KIND TO YOUR CEO WEEK

Be kind to your CEO week.
There's a new savage disease
going around and knocking those poor CEOs down onto the ground.
They're investing in a working antidote.
They might get the building up in 10 years.

Be kind to your baby week.
A little extra talc will get you a long way.
Don't pay any attention to all those awful rumors,
someone around here needs to keep a clear head.

Did the human ever finish his race?
When it finally all ends, who'll still be on their feet?

The information bureau's run out of words,
the future merely improvisation.
I'm saving my only good joke for later,
just not time for it yet.

It'll get a lot colder.
Birds will fall dead from the sky,
then you'll need a big strong drink
and the key to the city.

Pay attention, baby.
There are so many locks
you just might free yourself completely.
That day will be something;
the banshees will flee.
You'll never get overdrawn at the bank again.

S. A. GRIFFIN

LOS ANGELES, CA

THE DIGITAL KIND

Sparked by the Internet, this print material followed no straight lines, smashing against computer screens spreading like a million pregnant spiders, the virtual progeny scrambling to cover the world with lines. Sometimes we get hit by lightning. Sometimes lightning lights up the sky to show the way and hell freezes over. The best is that we all pack our own heat as we ease on down the superhighway taking shit apart and putting it back together again, wild-eyed mechanics attempting to decode what it is we think we've been driving all this time. You got to hold on with both hands and ride. Get your head out and into your heart, learn to read the smoke so that your one foot in front of the other falls feet first thru swinging doors working the some like it hot wheels of perpetual emotion machines. It can be a mad party at best, and would be a great disappointment if it were not. And therein lies the old the rub; pork is so much sweeter off the bone when smoked properly. Just smoked part of a fatty; my weapon of choice. Puffed outside where a steady rain continues to answer the thirsty land. Took a few hits, all she wrote. It's a beautiful thing; can you feel it? In an open act of poetic terrorism I knocked on the neighbor's door across the hall. His head popped out like a Jack In The Box clown. "Hey man, kill this," I said, handing him the smoking gun. "Thanks!" He took the burning bone disappearing behind the door with murder in mind. He loves football and weed and on most Sundays this time of year you can hear his praises roaring thru the building towards anonymous shores. Plug in, boot up and drop out. The holy cow jumped over the shark by the light of the virtual moon.

IRENE CAESAR

DENVER, CO

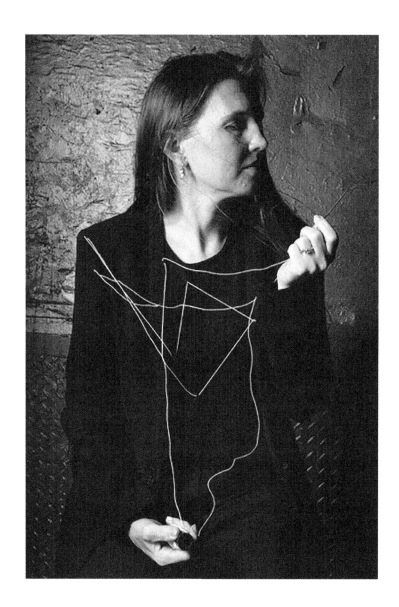

NATALIA KOLODZEI CONTRIBUTES TO KANDINSKY

Digital photography

L. BRANDON KRALL
YONKERS, NY

STRING THEORY

Video still, digital print

JOHN S. PAUL
BROOKLYN, NY

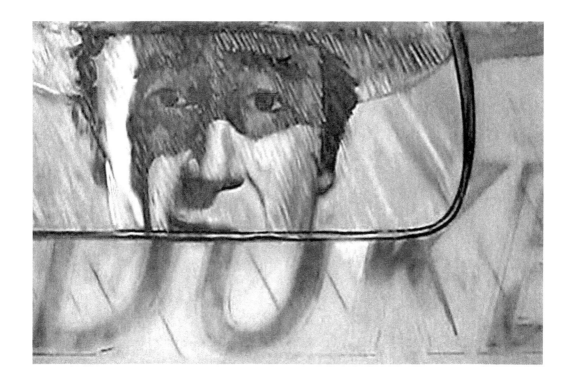

JOHN WAYNE

Painting

DEAN PASCH

MUNICH, GERMANY

JOHN WAYNE'S WHISPER

Between day
Interior. Night

There are a series of folded pieces of emptiness, stacked one on the other—intimating silence, wrapped in a noise resembling an eye-lash falling on a cheek.

The scene fades to red, very slowly; like memory on the tip of a tongue, the size of Saturn.

A lonely white Enter: Sheet

The sheet floats several inches above the floor (which is littered with used dreams). An out of shot, wild sound, synchs with the sheet's creases, a voice that is an avalanche, announces that the departure of the train to nowhere has been delayed. Further announcements will arrive in twenty years. The creases smile wryly and disappear, as the sheet drops to the ground, covering most of the used dreams.

A perfect, miniature copy of Notre Dame is wheeled onto the scene, by a miniature, animated copy of the statue of Liberty—a plaster cast version, used to design the one that was subsequently made in France and erected somewhere in a land of states, not really united, far away.

The ghost of John Wayne appears, and walks lethargically down the series of folded pieces of emptiness and whispers

"I am searching for the sound of eternity, on this stage of used dreams. Talk low, talk slow and don't talk too much" (the advice at the end being a direct quote from his own lips prior to him becoming a ghost).

A perfectly silent, white, nowhere,

Exterior. Never

The end credits roll:

GORAN LISNJIC

SLAVONIA,CROATIA

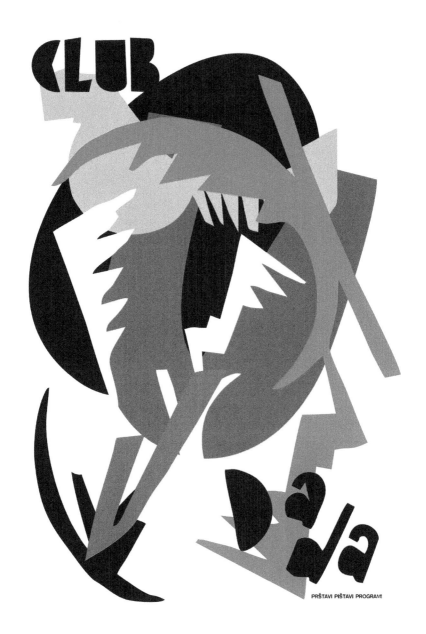

PRŠTAVI PIŠTAVI PROGRAM!

DADA CLUB

Digital painting, 330 mm x 482 mm

CHRIS MANSELL

BERRY, AUSTRALIA

having despised
drawing thought
through appolin
aire speaking a
loud century go
ne like a zip i
t is those scra
ps of scratches

an arc bridge c
onsecration kee
ping us looking
long past the l
ookby date moun
tains except by
their own timet
ables change on

ly themselves i
n the looking n
ot wanting huma
n gaze fretting
like bees at th
eir faces hills
and trees do wi
thout damned pi

ctorialists nit
picturing stone
s and here appo
linaire speakin
g one hundred y
ears too soon p
oets squeeze ve
rbs from stones

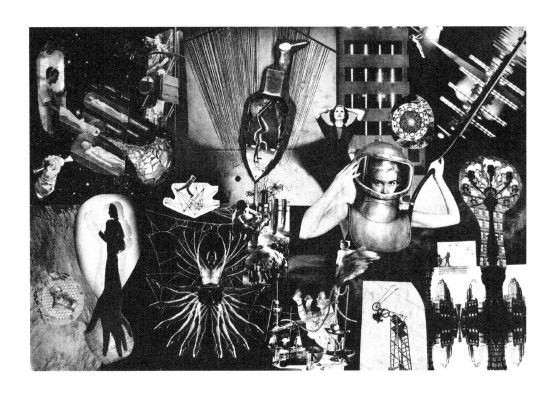

MUSE OF CREATIVE INVENTION

Photomontage & mixed media on canvas, 16" x 24"

YURIY TARNAWSKY

WHITE PLAINS, NY

HUNGER

A hungry color
was looking
for its own mouth
to open it
in the direction
of his bride
between skyscrapers
and souls
made of stone.
On the edge
of a park
painted black,
where retired paint
comes to die,
he asked a policeman
who'd already been reached
by the overripe
root
of an abyss:
"Where
did she go
with the red suitcases
in her joints?"

"There came a taxi
the color of despair,
the moon
was hiding
behind clocks,
and they vanished
behind the left side
of her head."

JANE LECROY

NEW YORK, NY

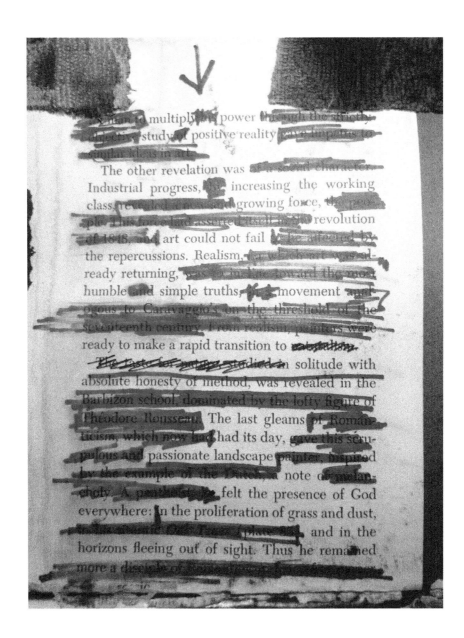

HORIZONS FLEEING OUT OF SIGHT

Cross-out poem

GIOVANNI FONTANA

ALATRI, ITALY

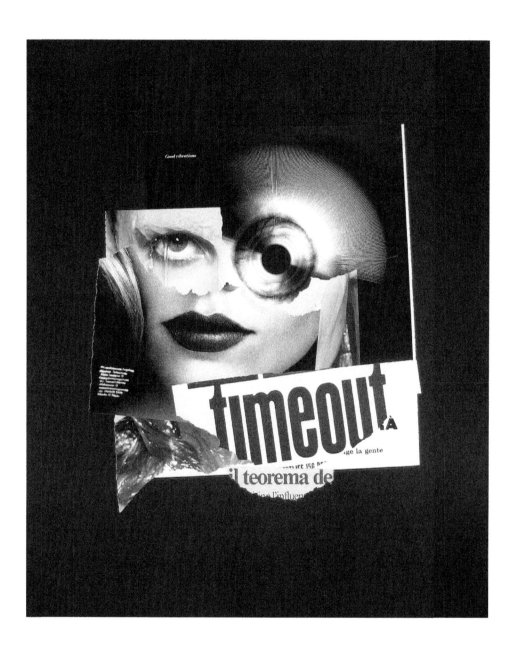

TIMEOUT

Visual poem

BEN STAINTON

SUFFOLK, UK

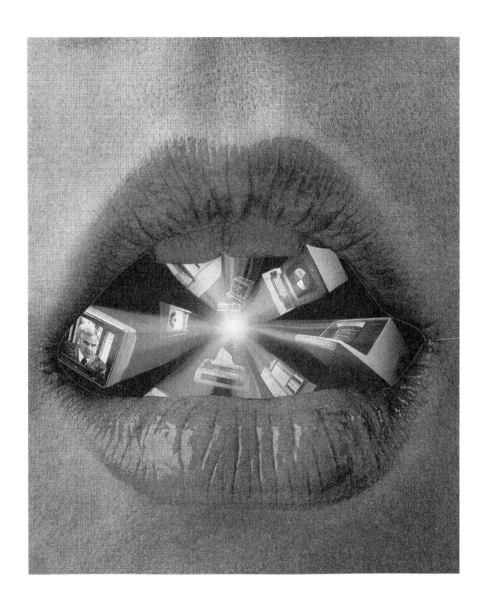

THE CONVERSATION

Digital photo collage

DUSKA VRHOVAC

BELGRADE, SERBIA

THE NET

This is the net of your dreams.
When your name rang in my ears
like April rain on the roofs of Paris
which flooded the time of my longing

when, in your night, shut in a cold
and half-imagined reality of a province
you trembled so much that my screen shook
and the milk of liquid crystal overflew

and soaked this hot Belgrade night
with yet another deceitful feeling of eternity
that is the moment this brittle unreal love
was born thanks to the new technologies.

You burst into my life with the heat of the ripe summer
as if you could save yourself only in its glow and you
immersed yourself in it completely like a fetus in a womb's water
overtaking my bloodstream and the rhythm of my heart.

But this net is only a network of your dreams—
mine are spread over the nets which are primeval
and no technology could be rescued from being sunk by them.
Only an unawakened heart could catch them with ease.

(Translated by Vera V. Radojević)

FORK BURKE

BIEL/BIENNE, SWITZERLAND

FICTION MIRROR

Cover my mouth with laughing

who

not phone comfortable—you carry it

Confront the comforted

leadership the wounded

and if the intelligence was

Unemployable

there is a point—you need it—we am we

Black Milk enter

laughing includes those people in the lobby

and internalized

believing—take reality for example

apologize

I will start with a primitive poem I want my machines

And this time his voice heard nothing

All I need is right here in my pocket

Don`t kill yourself—a miss is as good as a mile

You want to tell me something—each little circle got a letter on
 it

So let's have it

No need no want

my medicine That I are

Telepathic to the bone

I am not able to separate something that is not separate

I began to understand something more

than a revolution unless I leave I can`t

understand a word you say

MICHELLE MULLET

NORTH READING, MA

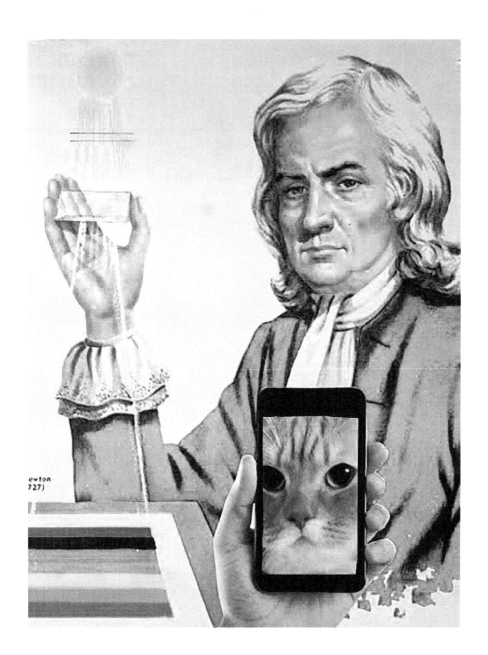

EL DISCO DE NEWTON

Collage, glue, vintage scientific journal, cat pic 6" x 7"

DAVID HUBERMAN

REGO PARK, NY

June 1991

TO THE TENANTS OF THE ANITA APARTMENTS:

I WISH I COULD BE LIKE DR. DOOLITTLE.

HE LOVED LIVING "WITH THE ANIMALS." IN SOME WAYS I AM LIKE HIM. I DO
LIKE LIVING WITH CATS, DOGS, EVEN MAYBE HORSES, COWS....

HE LOVED ALL ANIMALS. UNLIKE HIM, I DETEST LIVING WITH P I G S ...
THEY ARE FILTHY ANIMALS. I HATE LIVING WITH M I C E AND EVEN WORSE,
R A T S... COCKROACHES ALSO ARE NOT PRETTY. IN FACT THEY ARE VERY
UGLY.

THOSE TENANTS WHO LOVE LIVING WITH THESE DIRTY, FILTHY, UGLY ANIMALS
AND BUGS (AND THERE SEEM TO BE MANY ON THIS FLOOR) HOW ABOUT YOU LEAVE
THE GARBAGE IN FRONT OF YOUR DOOR SO THAT THESE PESTS CAN CONGREGATE
AROUND YOUR APARTMENT - DON'T SHARE THEM. WE WHO DESPISE THESE BUGS
AND ANIMALS (AND THERE ARE MANY ON THIS FLOOR) WILL CONTINUE TO THROW
OUR GARBAGE DOWN THE CHUTE AND KEEP THE COMPACTOR ROOM CLEAN - AS IT
SHOULD BE.

TENANTS UNITE -- LET'S GET RID OF U G L Y. IF YOU SEE ANYONE LEAVING
GARBAGE ON THE FLOOR OF THE COMPACTOR ROOM, PLEASE GIVE THEIR NAME
AND APARTMENT NUMBER TO THE MANAGEMENT. MAYBE THEN SOMETHING CAN BE
DONE.

DOWN WITH FILTHY ANIMALS.

TO THE TENANTS OF THE ANITA APARTMENTS:

Found poem

I'M DADA

Infographic

CHRISTIAN GEORGESCU
LOS ANGELES, CA

cue.alt.del

~~I am deleting my account.~~ **Goodbye cruel www.orld**
cue the violins, cue the violence
I know my cue 4 a dramatic entrance + an emotional exit.
Or is that an abdominal exit wound
cue dramatic entrance music
Either way, I Hope you don't mind if I make a quiet exit. I'm going out.
The nightlife is a highlight **2** an otherwise quiet life. A quiet exit **2** a silent life.
cue emotional violence
This is a violent knife I've got **2** my throat. My wife is not @ home.
I am not @ home in my life. That's all she wrote.
cue emotional violins
This communiqué comes w/ no strings attached. That would be 2 much commitment !
I'm on a 2 year agreement. *Which ended a year ago* Now I'm on a month 2 month,
wk 2 wk, min 2 min living day by day + paycheck **2** paycheck.
Minute by minute I live **4** yr text, since **I never hear from u** I never live.
But I don't give **2** Shuggas Honey **IT Should be here any minute** now!
In the **meantime everybody** wants 2 sex me 'cuz I'm a text object /brēth/
I don't **object** 2 the pretext 'cuz I'm on a **2** year agreement /brēth/
I live **2 disagree + beg 2** differ. The inference in this instance is I am not a chooser
I am a beggar so I take what I can **get + hate the rest**. If u don't like it just say *Next!*
Which is what I think u said, in yr last text. Which I never got brēth
cue emotional violins, cue emotional violence
This is **mm/yyyy life!** This is **mm/yyyy text!**
Honey, I **hope IT** gets here soon cz the paramedics **cannot fix this** /brēth/
cue emotional violins, cue emot

CUE.ALT.DEL.

Digital poem

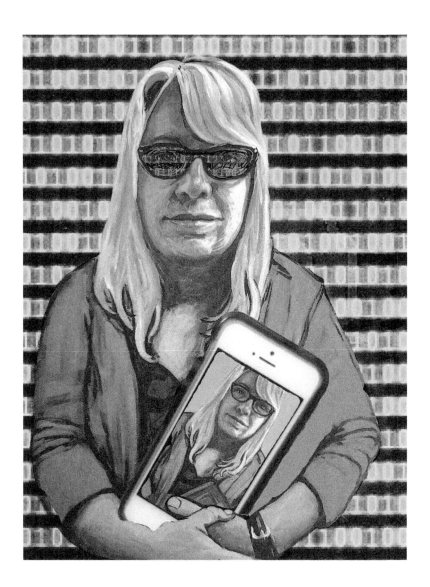

COLD CALLING

Acrylic on vinyl, 35" x 25"

JOAN HIGUCHI
WEST ISLIP, NY

A WORD TO THE WIRED

Sound spilling all around

your head is wired,
blocking out the meaning
of our words,
the jolt of rhythm
substituting for
liquidity of speech

no thought required

when you're wired
you put all dreams aside,
avoid our touch
the feel of flesh,
turn inward 'til
there's no one
in the world but you

and you may not be
someone you would care
to know

MARK HOEFER

SAN DIEGO, CA

STRIKE ANYWHERE

Watercolor, 12" x 16"

MARTINA SALISBURY

BROOKLYN, NY

CELL MATE

trying to sleep had always been difficult,
but there was a voice now,
urgently screaming her name,
keeping her more awake.

not the old voices in darkness, too far even if next to her bed.
she had always wanted them closer,
and would search the houses to find them, if they were too quiet.
sometimes she brought gifts. animal sacrifices.
then she slept.

there had been years of dreams, a lifetime, laughing now,
singing as they fade into new air.

soon midnight, the voice keeps her from sleep.
glowing bright, it commands attention,
and will not stop screaming her name.

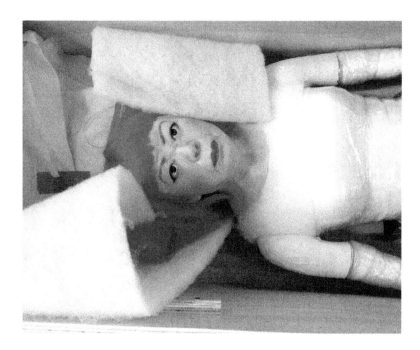

YK LV #2

Photograph

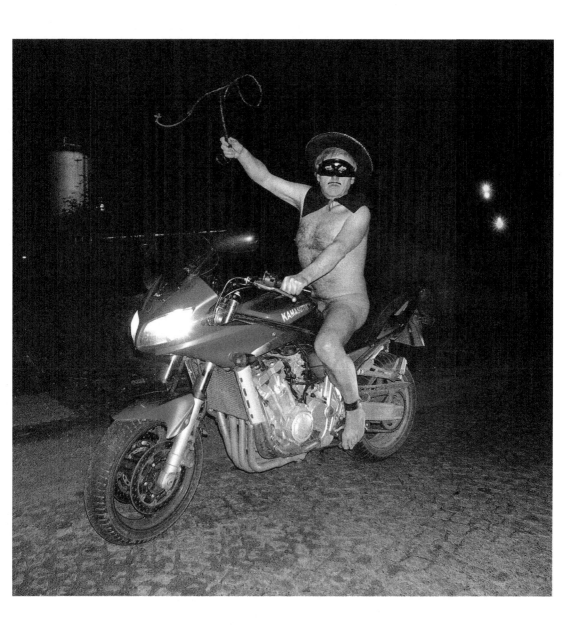

RAID DE PROTECTION–DEFENSE

Photograph

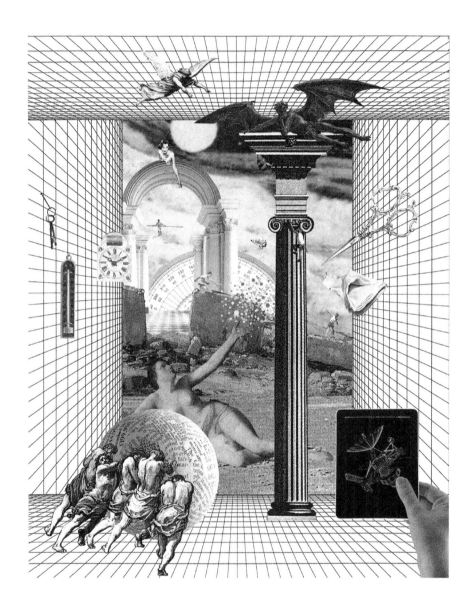

TECHNO-DEATH

Digital collage

ROBERT HIEGER

NEW YORK, NY

DONGLES, DANGLES, AND BEEPS

Tantalus stretches his arm from antiquity
Dangles a dongle of USB secrets
Mangles a moment of tête-à-tête
Instead we have SMS, latter-day S & M.

Young couples avert eyes from each other, gaze lovingly
At iOS vistas whose screens they now diddle
Coo and giggle over vapid missives transmitted cross-table
Is this romance conceived by a cyborg Clark Gable?

"I am *not* a Luddite!" cries the man behind the curtain
Accompanied by a whir of clicks, flashes and beeps
"I'm an artist, a lover and scientist *dazu*!"
Yet hidden from all in a sea of bleeps.

Vapid sighs issue as each message is read.
If medium is message, this message is dead.
With a beep and a whoosh, response message is sent,
in fourth wall of persona there is scarcely a dent.

Our devices our vices that ice and divide us
Yet the scientist, artist and lover *dazu*
Need not hide behind curtains as he's wont to do
His vices, devices and crisis not worth the fuss.

Liberate the device from the inspired creator,
Wayward dongle from the port that it dangles!
And will we find that device is a tool that extends us,
Not rule of law from a fool whose bluster suspends us?

AVELINO DE ARAUJO

NATAL, BRAZIL

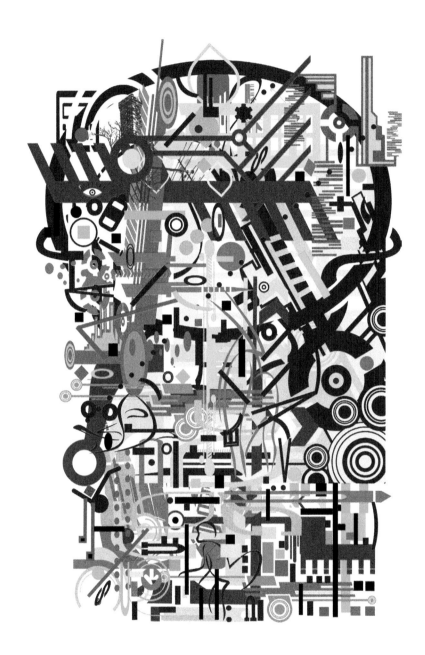

FRANKENSTECH 23

Digital illustration

DD. SPUNGIN

VALLEY STREAM, NY

DATA NEVER DIES

This world we visit for one lifetime
 (Cats, nine times to get it right)
Experiments seek longer life

Philosophers ask,
 What's the big deal
Why wish for endless angst

Long after we close shop
 and bask in emptiness,
our data spills,

covers cyberspace
 with secrets
we thought safe in death

Data Frankensteins become our masters
 Our ghosts, forever damned
to serve . . .

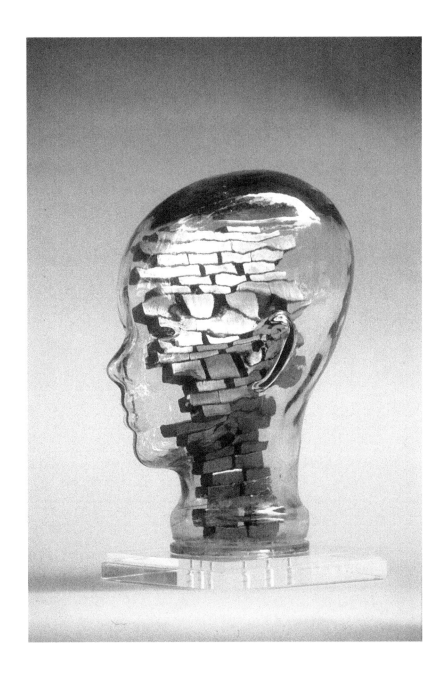

MURO

Glass and iron, 19 cm x 28 cm x 14'4 cm

GOOGLE IT

At last. opened floodgates of hell, that much-doubted place.
Fire up the jets, pour toxic churning in fertile sea of soul.
drink the blood of old dictionaries, medical, science and biology books mutated into meaningless non-beliefs, This ain't right. shred and sliver, what thin bare wire of intellect frayed at the ends yet still plugged in you clutch trying to spark a clear Why? self-destruct, and why? extinction begin?? fault? flawed, us, in a mere million years? Are we standing atop other tried and died? millions, billions, trillions passed in waning radiance, disinfected was reseeded by some unknowable source? answer, the Curse? Who is telling us versions, google.

why humans so badly dressed for the elements, ill-prepared, sadistic?
he begat him, and he begat him, and so on mistakes piled up, one atop another... forever standing in line at the company store. Trillions of failed endeavors.

reckoned with, forced to behave, made to see, beaten into submission, brainwashed, mind-controlled, googled, bribed, tortured, adled by brain altering chemicals, darpa, drugs, and various and too numerous to mention every-day poisons.
We have none. No tribe, hive, army, force. "every man for himself" we fall, all for one and one for all. noble vision of impossible we pretended all along, defense contractor google, serving and dying, black lung, broken backs, bad health, labor exhaustion myth of strength?? smelting us giant melting pot? extoll virtue of diversity. Google State Religion. will be zero diversity blended us all into one, bloody milkshake with a burnt offering impaled on a plastic sword, hot cup of genocide. expiration date stamped forehead discarded obsolete out to pasture pushin up daisies sold as is old-timer, you! Artificial ingredients titanium foil hat-wearing cousin of ape invasion now! Big dog untethered by google. Run for under the covers chased by cyborgian bed time stories bros grimm futuristic flying carpet cars. Rulers measure worth, nothing left. blood and guts slaughterhoused unmarked google grave slave race lost.

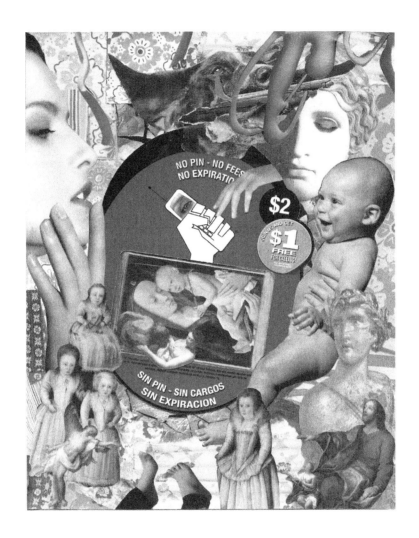

SIN PIN/SELFIE

Paper and paste, 8.5" x 11"

ZENON FAJFER

KRZESZOWICE, POLAND

3D-PRINTED KID

a 3D-printed kid longs for its compatibles
both mummies are away to earn paper and better ink
each is scrubbing floors on a different moon
dreaming that

one day

they will print their wireless baby
a domain with a garden and a sister
soon with the option of a brother

the 3D-printed kid drags itself
a chair

translated by Katarzyna Bazarnik

GIUSEPPE COLARUSSO

BOTTICINO, ITALY

TOUCH SCREEN

Digital image

VALERY OISTEANU

NEW YORK, NY

SURREAL COSMOS

(Letter to future generation)

Dear communards of Interplanetary Surr-existence

Resist, Provoke, Inspire and Enlighten

These are some of the tools for surr-future

We are all magically on the same frequency

And a desire to unite in a mind-revolution

Our nightmares live free in a space-time continuum

Sexualizing the masses through poetry and jazz

Slap the kitsch! Shock the taste of the techno-clones!

Surrealism cannot be kept as a pet or a caged animal

We must break the Freudian chains, a non-Oedipal rebellion

To conquer the inner and outer worlds! Divest eternity!

The system of totalitarian control must be subverted

The hierarchies in the arts must be dissolved or disabled

Negate the negation! Kill Death! Sexualize Sexuality!

Clairvoyance piles on the blindness of the computer

We have to get out of ourselves more often

The day when the planet stops and shows foretell love

All sacred monsters must retire, all believers questioned

Greetings intra-terrestrials and extra-terrestrials

Let's rock this spaceship, lets kick-it up a notch

We have arrived united, as a brotherhood of one!

IT CAREERIST

Digital drawing

MARIE LECRIVAIN

LOS ANGELES, CA

THE WEANING

<u>Day 1</u>: I logged off for an hour. I turned off my phone, computer, and tablet. For the first few moments, I felt liberated. After 20 minutes, my hands began to itch for the feel of the mouse and the tiny bit of endorphin-engendered gladness with each "like" I add to the data stream.

<u>Day 2:</u> I logged off for an hour-and-fifteen minutes. I sat in front of my computer and stared into the blank screen. I began to imagine a flow of witty instant messages from my boyfriend (I don't have a boyfriend). I envisioned the political sound-bites, the cat pictures, and the memes flowing in front of me—around me—and, without me.

<u>Day 3:</u> Today, I logged off for two-and-a-half hours. I went for a walk. There's a lot of action outside. Birds sang, people walked past me; real people, fat people, and old people. I spotted a woman whom I'm friends with on Facebook. She looked older than her picture. She looked sad and lonely. I wanted to introduce myself, but I thought that might creep her out, so I left her alone. When I came back to my apartment, I seated myself in front my devices for the next hour-and-a-half. I felt a pang of envy for what I was voluntarily missing. All those voices. All that information.

<u>Day 4:</u> I spent the morning listening to music; Peter Gabriel, The Beatles, Heart - my favorite cds have gathered dust for the last five years. I kept moving, my body spinning around the room until I fell down laughing, sweaty, heart pumping, out of breath—and alive.

<u>Day 5:</u> I left the devices at home. I took a book with me to a local cafe. I spent most of the day reading. I also watched people around me send instant messages to other people across the globe. An older married couple came in, bought two coffees, sat down next to me, and immediately ignored each other as they pulled out their phones and began to text. This made me sad.

<u>Day 6:</u> I went to the Sprint store. I bought the most basic cell phone I could find. Then, I went to Staples. I bought a notebook, pens, and stationery. I wrote my mother a letter, but I had to call her to get her new address.

She asked, "Why don't you just email me?"

"According to Wired, the new hip thing is to write letters," I said.

She laughed. "I'm glad you called," she told me. "You haven't been online. It's good to hear your voice."

<u>Day 7:</u> I walked to the post office to mail my letter. There were no lines. I bought a bunch of stamps. The clerk thanked me and asked me to come back again. I went for a long walk. It's early autumn. The leaves are falling off the trees. I went to the park. I sat on a bench. Nearby, children played baseball, shouted, and cheered each other on to victory. This is fun, the sounds of the voices of flesh-and-blood people. I opened up my notebook, uncapped my pen, and started to write. Dear Diary: My name is "I," and—

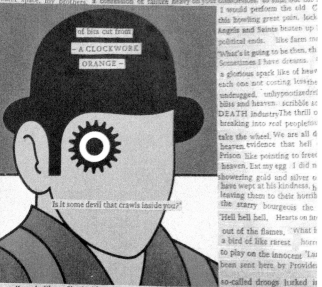

OF BITS CUT FROM A CLOCKWORK ORANGE

Cut-up synthesis collage, 12" x 8"

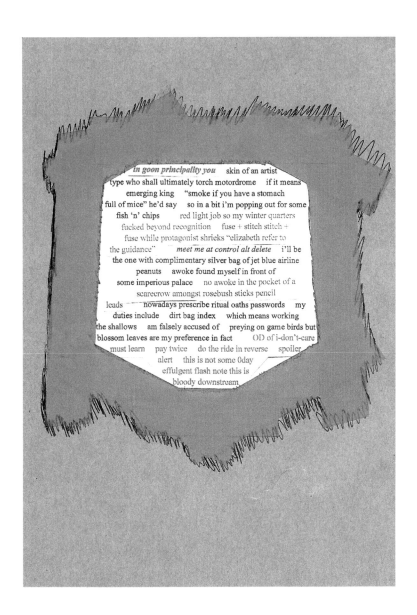

IN GOON PRINCIPALITY YOU

Visual poem

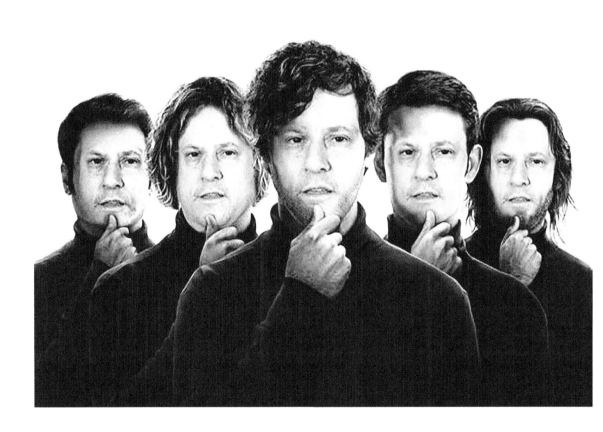

JOHN J. TRAUSE TIMES SEVEN

Photographer: Jessica Stroh / Model John J. Trause

CRAIG KITE

NEW YORK, NY

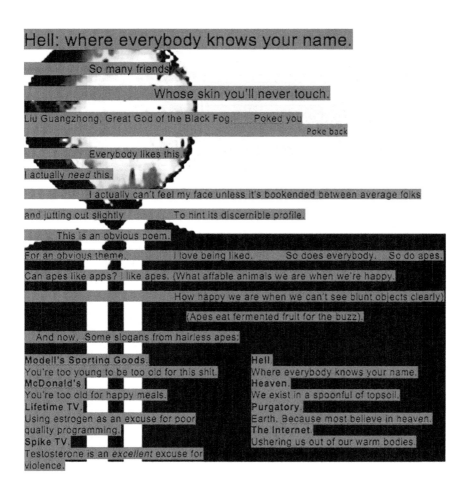

Hell: where everybody knows your name.

So many friends

Whose skin you'll never touch.

Liu Guangzhong, Great God of the Black Fog. Poked you

Poke back

Everybody likes this.

I actually *need* this.

I actually can't feel my face unless it's bookended between average folks

and jutting out slightly To hint its discernible profile.

This is an obvious poem.

For an obvious theme. I love being liked. So does everybody. So do apes.

Can apes like apps? I like apes. (What affable animals we are when we're happy.

How happy we are when we can't see blunt objects clearly)

(Apes eat fermented fruit for the buzz).

And now, Some slogans from hairless apes:

Modell's Sporting Goods. Hell
You're too young to be too old for this shit. Where everybody knows your name.
McDonald's. Heaven.
You're too old for happy meals. We exist in a spoonful of topsoil.
Lifetime TV. Purgatory.
Using estrogen as an excuse for poor Earth. Because most believe in heaven.
quality programming. The Internet.
Spike TV. Ushering us out of our warm bodies.
Testosterone is an *excellent* excuse for
violence.

HELL. WHERE EVERYBODY KNOWS YOUR NAME.

Word doc

JOHN M. BENNETT

COLUMBUS, OH

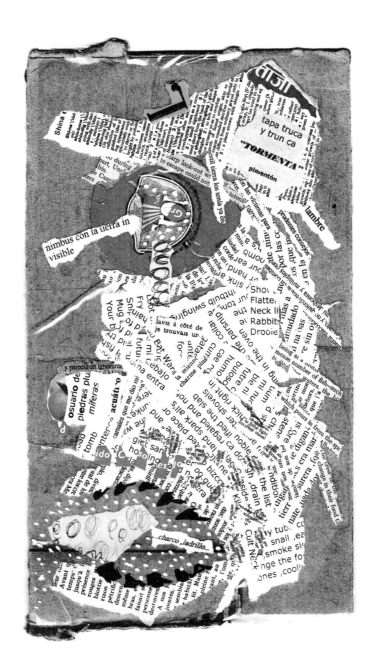

TORMENTA

Visual poem

JAAP BLONK

ARNHEIM, THE NETHERLANDS

CONSANGUINITIES

Visual poem

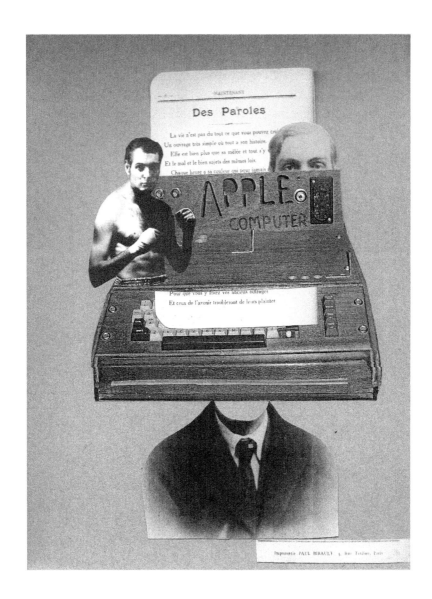

CRAV-TECH-ROLES

Handmade collage on paper

JOANIE HIEGER FRITZ ZOSIKE

NEW YORK, NY

Fahrenheit Forfeit the Glue

So it comes to this What do you wish to
communicate I have nothing with which to
educate or **inform anyone** that education
formed **who** is formally informed The
informat **has nothing to do with** the
education infovat The internet has **no**
information with which to freely educate
No information is available **to** inspect
the current abrogation Info for short
netiquette for conduct modification
indoctrination Artificial Intelligence
nation a preparation for **systemic**
prevarication The **banners** and popups
guide readers to accept a halo of
consumerization I have nothing to learn
or teach to inform **convey or preach,** no
speech No words **no** thoughts no drafts no
draughts no sots no **robots** Nothing to
educate nothing to insinuate nobody to
cunnilingate or fellate Somewhat deflated
to come so belated **uneducated** in thrall
To the panopticon over all watching and
teaching porning informing Reforming the
threshold via inculcation of a flaccid
faltering nation

FAHRENHEIT FORFEIT THE GLUE

Visual poem

BIBIANA PADILLA MALTOS

WESTMINSTER, CA

M

Visual collage

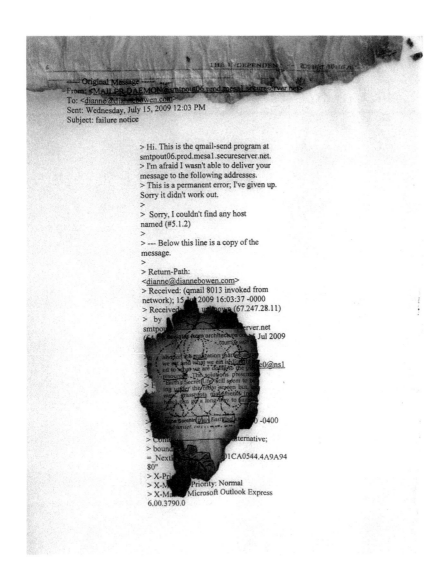

FOUNDLING

Found newspapers, bounced email, archival pen, original note poem on archival parchment.
Realize directly resources under roots move, we are life saving, 8.5" x 11"

JURGEN TRAUTWEIN

SAN FRANCISCO, CA

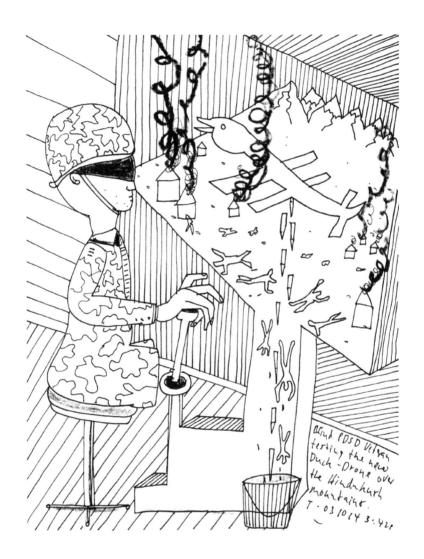

WARGAMES

Pen and ink drawing on archival paper, 8.5" x 11"

PAUL HAWKINS

BRISTOL, UK

LOOK MA NO BOOTS

we chew

 our fucking gums raw

high on nightshift cia amphetamine

 punch co-ordinates dial-up

a drone raid it's air-con dry

 four hours into a thursday

chemtrails trace lazy flight

 across morning's lapis sky

burning charcoal

mint tea

a palm full of figs

flies sand in the honey

a mother breast-feeding

eyes closed

 in the shimmy-shimmer

a gray-blue-gray-white sky

 two hundred and seventy nine

minutes of the simpsons later,

 (blink white-silver-yellow-silver)

all that's left out there is half a dog

ROBERT S. CANNADAY

PORTLAND, OR

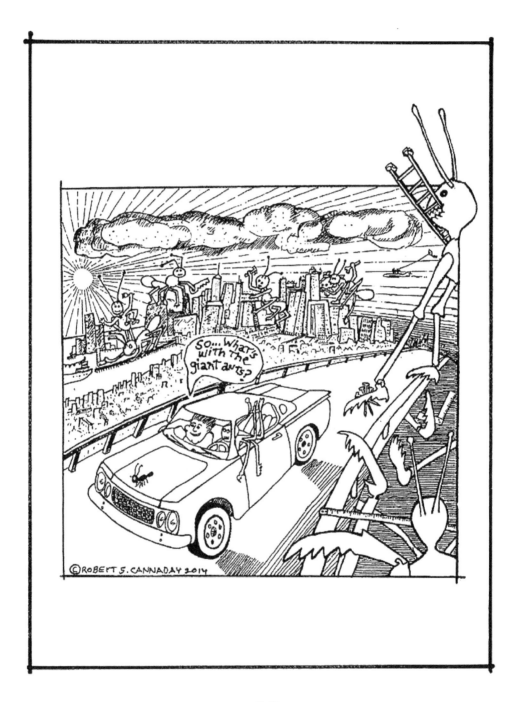

anticity

Ink drawing, h: 9"

LANCE NIZAMI

PALO ALTO, CA

ERROR-FREE

The perfection of an ant, a ruthless robot

How many of us dream of the perfection of an ant

How many of us wish we had perfection

How many of us wish we could intuit the right actions

Robot-like, we'd know just what to do

We'd know just what to say, and we'd know just when to act

Imagine us a colony, like ants

We need not be spontaneous; that causes so much needless stress

We'd cultivate familiarity

We'd all increase our gross efficiency

Eliminating insufficiency would be our goal

Why "need" when you can "share and share alike," indeed, why
 need

And once we think of grouping, then we'll all think as a group

We'll kill our apprehensions, intuit the right actions

Together we'll remove our dear outdated imperfections

So many are still left; so, let's aim for pure perfection

Together we will dream of the perfection of an ant

The perfection of an ant, a ruthless robot.

GEDLEY BELCHIOR BRAGA

DIVINOPOLIS, BRAZIL

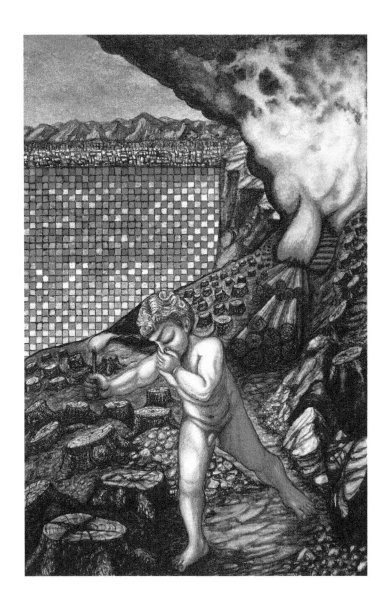

SEMIOTIC PYROMANIAC

Watercolor on Fabriano paper, 16 cm x 10.5 cm

DEATH FROM ABOVE

After three months in 'Nam, I realized, as a grunt I had two choices: work in an APC—armored personnel carrier—or become a helicopter door gunner. Hanging around in an APC was filthy work, especially during monsoon season. Looking for excitement, I opted to become a door gunner, even though I'd heard the old saw that a door gunner had a life-span of five minutes after takeoff. I never feared heights, and felt exhilarated when I sat on a huge mound of ammunition belts, since my M60 machine gun and the six-barreled Miniguns used the same bullets. I refused to wear a safety harness because I wanted maximum maneuverability. Sometimes we would fly behind a bait ship, whose purpose was to draw enemy fire. As soon as we were fired upon, I would begin firing back, the empty cartridges flying, at times burning my forearms. My biggest thrill was when we flew with other gunships, two, four, six of us, and would be given the order to destroy a village. One after the other we dove down, the two Miniguns each spitting out 6,000 rounds a minute, the two rocket pods launching seven rockets each, and me and my buddy on the other side of the copter, blasting away with our machine guns. It was the greatest adrenaline high of my life, and within minutes, the village was reduced to flames, smoke, and cinders.

LARRY ZDEB

TROY, MI

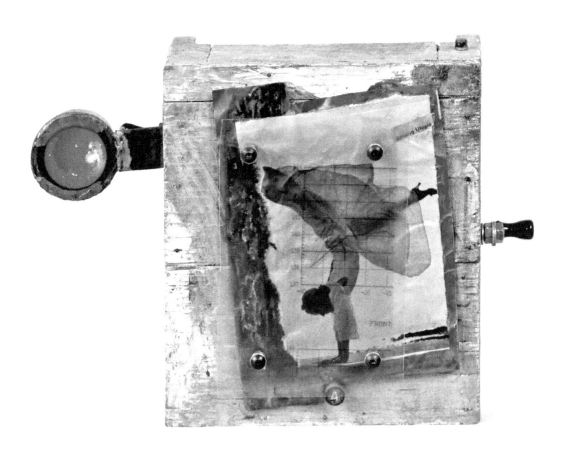

DANCING UTOPIA

Mixed media box with illumination, 6" x 9"

JAN MICHAEL ALEJANDRO
PASADENA, CA

ON THREE PHASE 240V

On Three Phase 240v

We are on our way to a massive showdown

We are engineered

We are the end result!

Four guys let loose a hail of gunfire

Making it very difficult to do my job

It would appear that this could happen

Four weeks

Don't tell!

For instance, if so, why was Michael shot too?

It's the one you lay awake thinking about.

No fear!

No ochlophobia

No coulrophobia

No problem taking on anything

Even when alone

Even when outnumbered

Aggressive predator

I'm proud . . . You're proud

Techno cruise

Captain sorrow

Unverified investment

You want honey . . . I want steel!

Let's freestyle on machines

Sequenced and sampled

Fire up the saw

I need to cut a slab of steel

Nightmare fuel

Confusion

Gone and lost for nine centuries . . .

On Three Phase 240v

CHRISTA BELCHRISTO

CHESHIRE, UK

UNLEASH THE MONSTERS

*Sculptural art representing the birth of photography and how this essentially
"unleashed the monsters" that were to eventually bring humanity
the mobile camera phone, laptops, and other "camera included" technology.
Sculptural artwork, using a vintage camera case and modern toy animals, 7" x 3"*

JEFF FARR

NEW YORK, NY

SUPER BOWL

Digital photo

PAWEL KUCZYNSKI

POLICE, POLAND

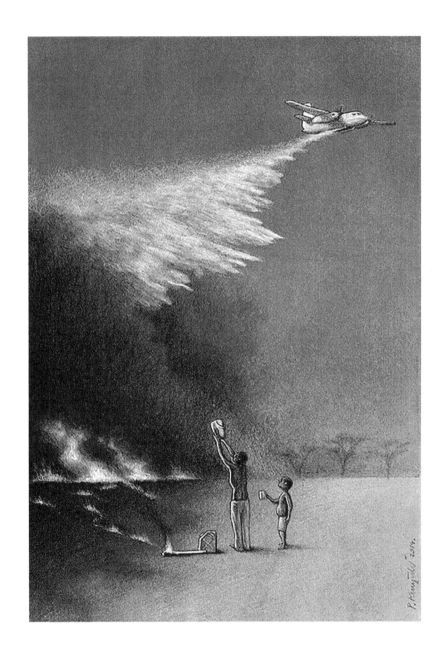

RAIN

Digital illustration

DAVID BARNES

PARIS, FRANCE

IF GOD HAS JUST UNPLUGGED THE SUN

If God has just unplugged the sun we have only
8 minutes of heat!
Each calorific unit radiated from a cooling sun
crossed space as infra-red in the fraction above
absolute zero.
Fifty three million miles in 8 minutes!
This world a staging post only on its journey
towards entropy
its long fall through the billenia
unwinding order, unspooling the tape of DNA
this universe shooting into decay
God's longshot targeted on nothing.

The lamps slowly going out across galaxies
dwindling to embers
to heat death
that state where
all energy is dispersed
so finely
as to be
absolutely
useless

KAZANORI MURAKAMI

HYOGO-KEN, JAPAN

A UNIVERSE

Paint on cardboard

DIANA MANISTER

JACKSON, NJ

VIRTUAL BOY

Digital art

MIKE M. MOLLETT

LOS ANGELES, CA

NO MESSING AROUND

the landscape is in your face…reptilian
wired with tempting IMAGES come-on complications
a fine design to twist out needs technology…

we are caught in the mix it's psychic mayhem

jumbled interrogation desire staples us into the flow
into an acceptable world there is no escape from these
c a l i b r a t i o n s
we just want to fit in good doggie

this land is our land man-made cornucopic
jam-packed roads to a similar place of happiness
I am unique take a drink a debit leap of faith
It's my birthday hooks itself into us friends on-line

the new series this year is even more violent (eat cake)
the sex almost gets us off (on the wish list)

the package deal starts out fresh as new love

the scene is not just the City out back is swamp
night after night we go on into the next day traffic
right wing or left we want our pictures gone viral
we want them NO MATTER WHAT

picture that

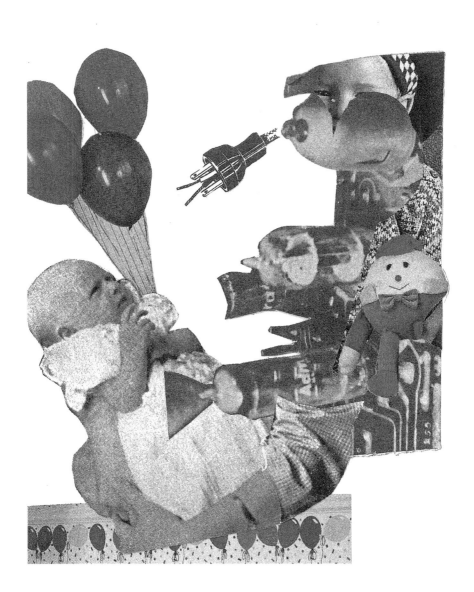

MILKMAID

Collage on paper, 4" x 5"

LINDA ALBERTANO

LOS ANGELES, CA

NIGHT STALKING ARMADILLO

Trust me.

I sped from NASA at a rate of 7 corpuscle-crushing
gravities for you
wearing an adult diaper with a pair of pistols
strapped to my hips.

Ah, hahahahaha!
You're #1 on my thrill list, Babe.

Trust me.

For purposes of National Security, I gotta hold you
in extra-sensory confinement. Ooooo.
You throttle my thrusters. Bad (!)

Trust me.

I must execute an extensive exploration of your
top-secret mystery parts. All this probing.
Are Martians at the controls here? Yet, no
one expects the Inquisition.

It won't be long now. Oooops . . .
It was an accident! Just cleaning my drone,
Hon, when it went off.

Sorry.

You shoulda stood your ground!

Trust me.

A. D. WINANS
SAN FRANCISCO, CA

TECHIE BLUES

I saw the best minds of my generation
turned into "tech" robots

sitting at Starbucks

making love to their laptops
their iPad, tablets, and smart phones
in their purses and backpacks

pause only long enough
to check their "Facebook" page
in between texting and Twitter

and Instagram

pasty white faces who feel the sun
only at the back of their heads

as they rush to communicate

with the living dead

Ka-ching Ka-ching Ka-ching

the new holy order

the holy of the unholy
wed to their tech toys

BECKY FAWCETT

LINCOLNSHIRE, UK

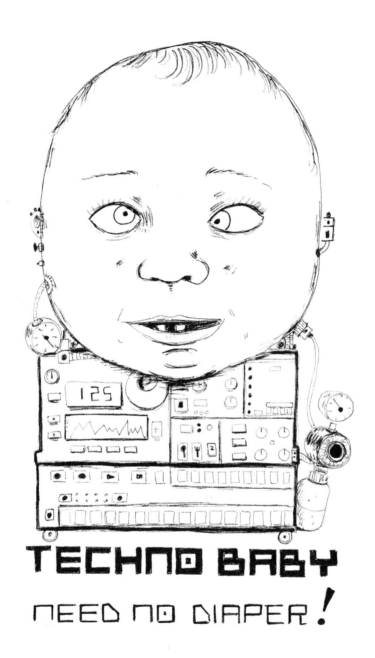

TECHNO BABY

Drawing paper and pen, A5

CYNTHIA TORONTO

SACRAMENTO, CA

ETERNAL CONNECTION

(inspired by the Paris terrorist attacks, January 2015)

He and iTunes became one
uniting notes between his eyes
melody enveloping his spirit
accompanying his quick grab
of the chips and soda snack
off the shelves at the Kosher deli
He heard nothing but his own
self-possessed beat of
his favorite song blaring in his ears
when he was shot by the
stranger in the next aisle
gunning out his music forever

IULIA MILITARU

BUCHAREST, ROMANIA

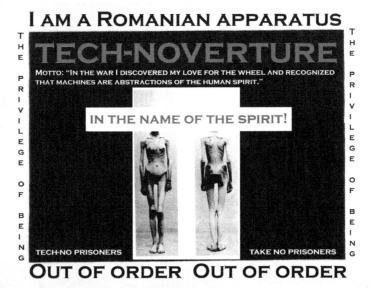

TECH-NOVERTURE

Digtial collage

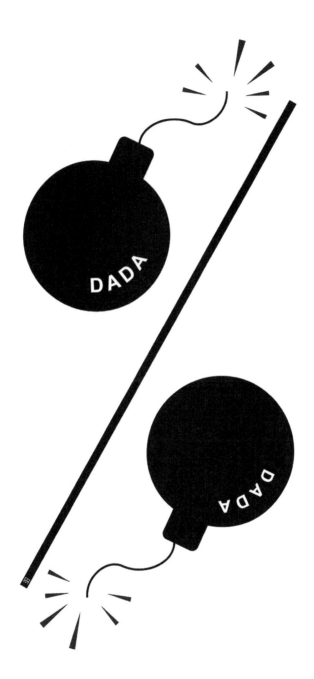

CHRONOMAN

Ink on paper

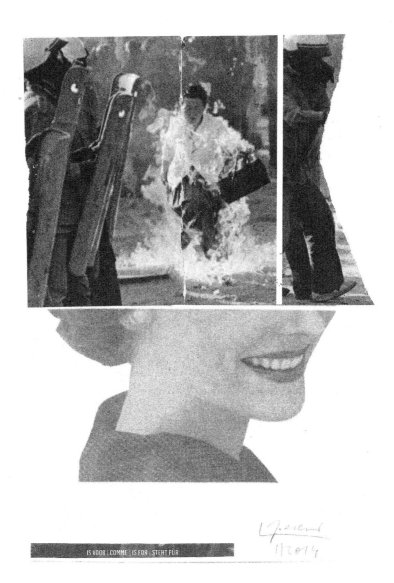

IS VOOR | COMME | IS FOR | STEHT FÜR

IS FOR

Re-poesia visiva (collage), A4 (30 cm x 21 cm)

ANOEK VAN PRAAG

NEW YORK, NY

THIS

This need this cannot last

This longing for eternity

This pain imprinted consciousness

This killing everywhere

This war against humanity

This madness overlay of love

This day the color changed to gray

This act so deep so steep a fall

This emptiness so stark immense

This silence rupturing ear drums

This torture of the animals

This desert so much space alone

This tear should change the sand to moist

This fantasy such meek attempt

This truth remembered nothing stays

This might be how survival works

This steadfast trust

This too will change

This shift will come

This too . . .

WESLEY RICKERT

ONTARIO, CANADA

```
                                        Author
         How Do I become A Prominent Swedish XXXXXXX & Poet?

         Is that a woodpecker or a sparrow?

         A smoking jacket is for domestic leisure!

         I think I will wake up in a Japanese slick & eat a pear!
                      my smoking jacket
     And The collar on XXXXXXXX is a great pattern white flannel mornings!

     And   There!s plenty of yatching where that brandy & soda came from!

         Fields plant themselves in silos of swaying soy bean!

         How far is Ottawa? I believe my stomach is upset!

         Is this Monday or Friday? Why not ask Samuel Pepys?
                             A             Zodiacal
         Not so fast! Is this XXX switch for the XXXXXX light?
                 dark is XXXXXX          sunset
         My XXXXXXX XXX tired & this XXXXX is moldy!(?)
                     concrete

                                        cartoonistXXXX peel
         Did you ask the cashmere French XXXX to XXXXX hard?
                                              (Conflagrations!)
     Because  The cuffs of Orion are clearly visible tonight? XXXXXXXXXXXXX

         My barefeet & elastic loop as protection from the rain?
              fool  escapes              brocade?
         What XXXXXXX XXXX with common-place XXXXXXX A shaving coat?
                              &              deer & the rats(won!t)
         Again the joy of slippers! Again the XXX XXXX XXXXX  play!(?)

         XXXXXX Puzzles
         XXXXX of speech? Irony? Anti-climax?, Rhetorical Question?
                                           Cordu^roy paradox?
         Simile?, Personification?, Exclamation? XXXXXX XXXXXX
                                                 XXXXXXXXXXX
         Large rented buttons? The flow of milky XXXXXXXX  wood pellets?
                                                 1/4      Block-houses?
     The Onomatopoeia for dirty ashtrays? Apostrophe?  Guady XXXXXXX

         Is it noon yet?

         January 8, 2015
```

HOW DO I BECOME A PROMINENT SWEDISH AUTHOR & POET?

Paper and a Royalite'65 manual typewriter, 8.5" x 11"

ALEX NODOPAKA

LAKE FOREST, CA

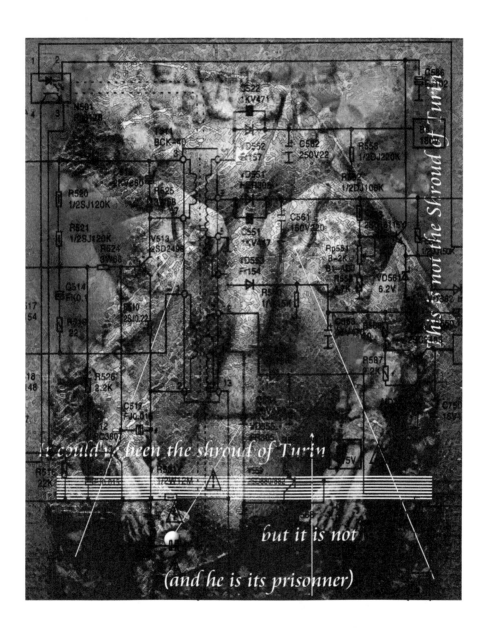

**IT COULD'VE BEEN THE SHROUD OF TURIN
(BUT IT IS NOT) (BUT HE IS ITS PRISONER)**

Mixed media, cloth, computer graphics, acrylics

JOHANN REIßER
BERLIN, GERMANY

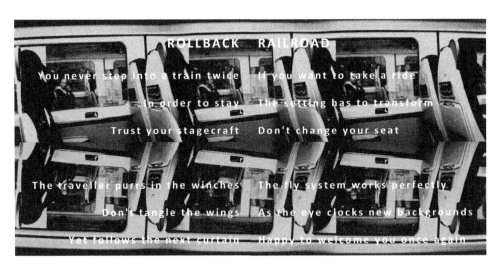

ROLLBACK RAILROAD
Digital collage pdf

BAAM aka MARIA GARFJELL
STOCKHOLM, SWEDEN

PHOTO 1
Digital photograph

MARC OLMSTED

OAKLAND, CA

AS THE CROW FLIES

The Eqiphany

(one "p" backwards)

appears on the telescreen chair

in front of me

in the disco light

of the trendy airline cabin—

now a crow

& the Dark Queen

with radiant emerald hands—

now a warrior marching

through fire

TOUCH ANYWHERE

TO BEGIN

PETER CICCARIELLO

ASHFORD, CT

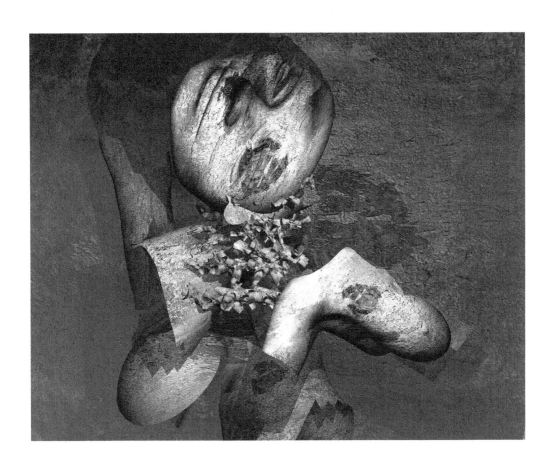

NEW-MAN NEW-WOMAN

3D digital collage

FREKE RÄIHÄ

DEGEBERGA, SWEDEN

LUNA – FOR MARIANA PALOVA

Definition: Thank you for your application. We will process it
shortly.

1. from the alchemical silver, meaning:
2. late for the ecclesiastical, the crescent-shaped receptacle
 within the monstrance, for

holding the consecrated phallus in an upright position.

(Processing)

Luna presence or having the appearance of

(as an adjective): Ages; there is breath, there is femininity; A
crow/fistula.
(as a modifier): Scenting; There is unity of pressure;

Subsidiary: Man is the violent beast. The sons of lilith; the
daughters of lilith.

Related: argent, brotherhood, the need for soap.

Synonyms: City lights; ancillary; denoting the 36th in a series,
especially in an annual series; canyons of perpetual comings; the I
of need/y; mirroring stars; fe-/line/-male: (noun—to, against); the
serpentine rainbow. The balance—as a part of speech:

(noun)
There is only apricots, there is the makings.

Text in honor of Mariana Palova, Mexican artist.

MATTHEW HUPERT

NEW YORK, NY

SURVIVAL OF THE SEXIEST

Mixed media

ADEENA KARASICK

NEW YORK, NY

FROM
CHECKING IN

William Wordsworth is wandering lonely on i-Cloud

Jacques Derrida's Glas is half full (but his copula runneth over)

H.D. is now available in H.D.

Bertolt Brecht just verfremded himself

Alfred Korzybksi is binding his time

Kurt Schwitters is saying it with stickers

Hans Arp lost his Sculpture in the Forest but George Berkeley can hear it

Nude is descending a staircase to heaven

Marcel Duchamp and Merv Griffin shared The Bicycle Wheel of Fortune

but Vittorio De Sica stole it.

The The likes there is no there there

and was just tagged in poem beginning The

Robert Frost and Jack Kerouac are On the Road Not Taken

Decartes is before the horse

CATHY DREYER

WANTAGE, UK

IN SEARCH OF AN ENDING

About 474,000,000 results (0.37 seconds)

Ending—RobotAcid

Ending Synonyms, Ending Antonyms I Thesaurus.com

Ending—definition of ending by The Free Dictionary

Ending—Android Apps on Google Play

Ending I Define Ending at Dictionary.com

Choose your Own Ending The Game

"Interstellar" Ending & Space Travel Explained—Screen Rant

Happy Ending (film)—Wikipedia, the free encyclopedia

Happy Ending (2014)—IMDb

Images for ending

More images for ending

Searches relating to ending

ending thesaurus	inception ending
ending a letter	sopranos ending
lost ending	avengers ending
ending a relationship	me3 ending